Mateusz Urbanowicz

Uncollected Works 2010-2021

日本散步

Mateusz Urbanowicz Sketches Collection

作者　Mateusz Urbanowicz

譯者　張成慧

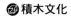 積木文化

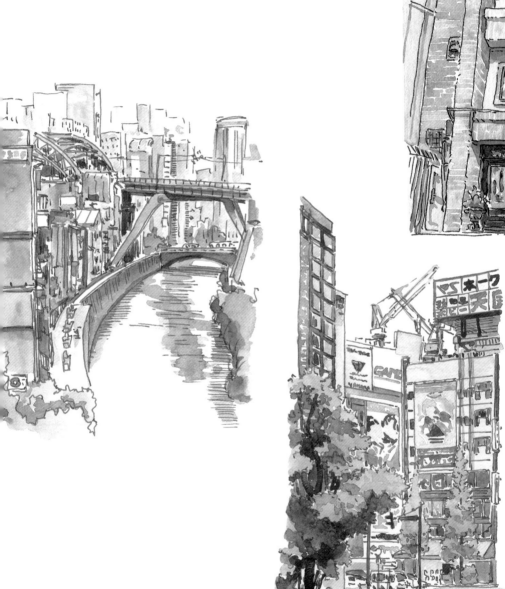

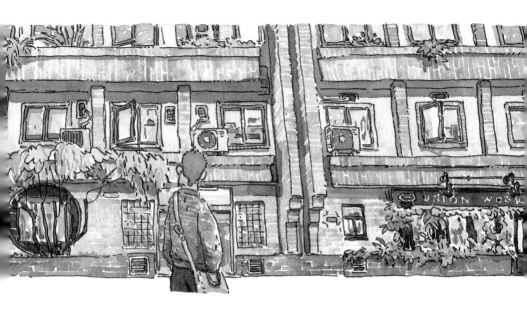

(Left) One of my favorite sketch spots in Tokyo is what's left of Manseibashi Station – now a fashionable furniture store under a railroad.
Even in busy places like Akihabara, where everyone's always rushing, it's possible to sit down and sketch a little.

（左）舊萬世橋車站是我最喜歡的東京寫生地之一，現在高架橋下變成一間時尚的家具店。
這裡跟附近的秋葉原一樣人來人往很熱鬧，但卻可以好好地坐下來畫畫。

A completely made-up Tokyo cityscape.

靠想像所繪製的東京市景。

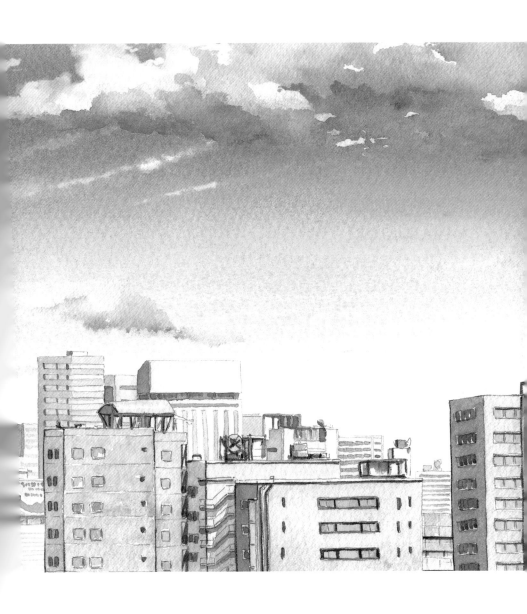

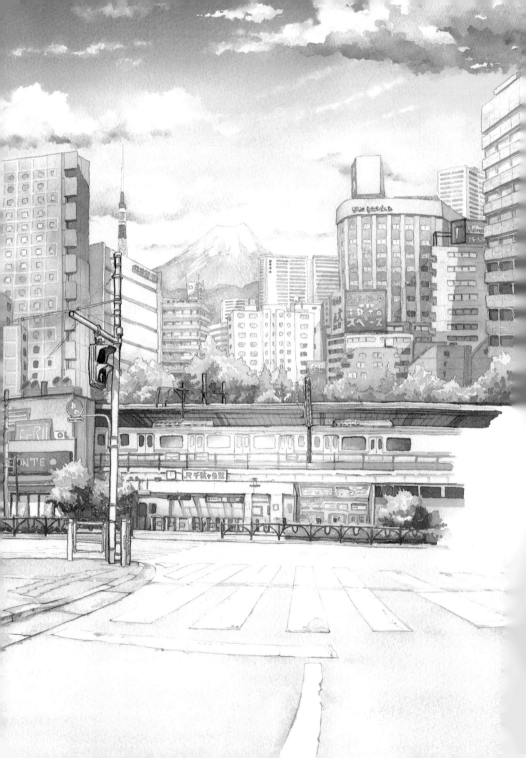

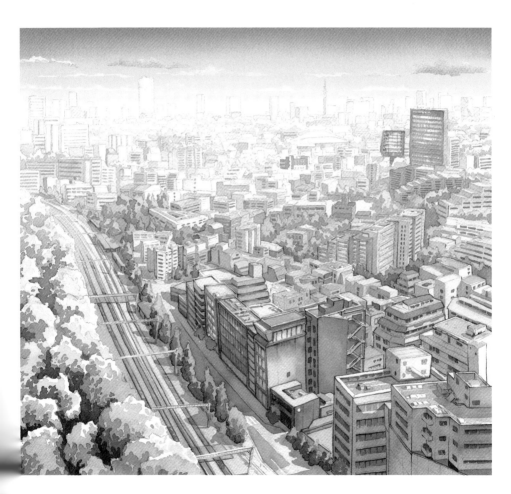

A poster background and cityscape shot I painted
for the "Susume, Karolina" animated short.

為短篇動畫〈前進吧，卡洛莉娜。〉（すすめ、カロリーナ。）
所繪製的海報背景與街道場景。

I constructed this strange corner out of elements I like. One often sees salarymen looking a bit haggard lingering in weird liminal spaces like this.

我把一些喜歡的要素組合起來，繪製了這幅奇妙的轉角風景。我常看見面露疲態的上班族在這種古怪的地方閒晃。

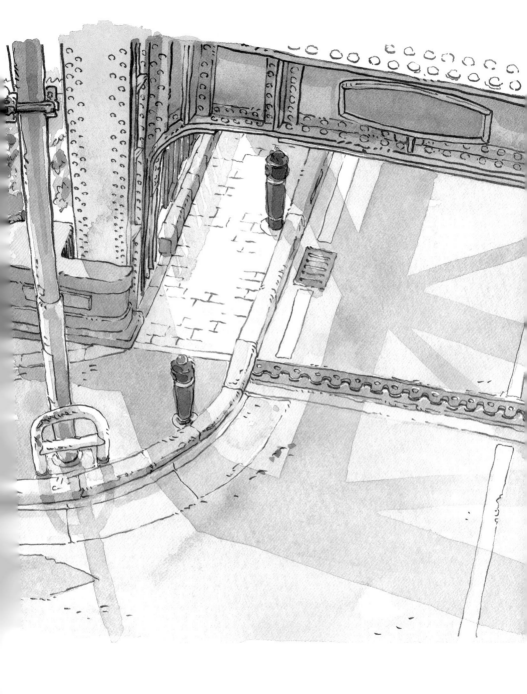

There are rare moments when Tokyo's hodgepodge architecture speaks to me, begging to be painted. It might be how the composition of the scene itself comes together, or how the lighting at a specific time of day hits the buildings just right. I gather these moments into my imagination, storing them for use later on.

有時候，我會聽到東京混雜的建築物群對我說：「來畫我。」時而是映入眼簾的構圖本身，時而是當下打在建築物上的光影。我總是會將這些轉瞬之間收藏進想像力之中，之後再拿出來用。

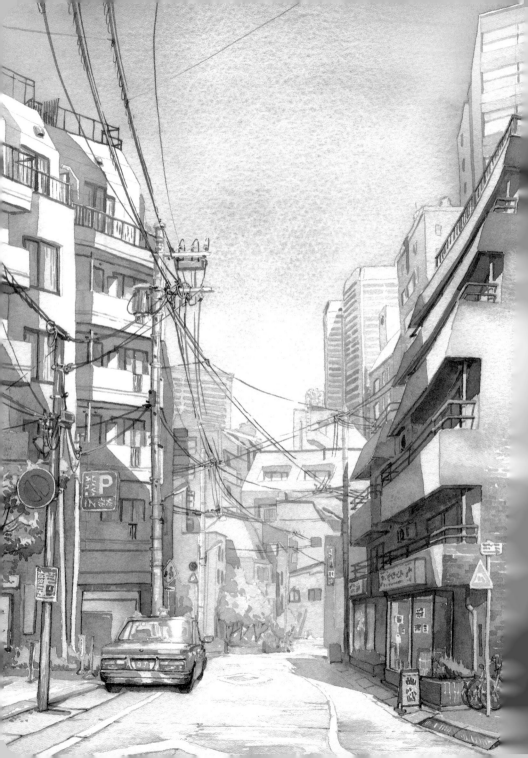

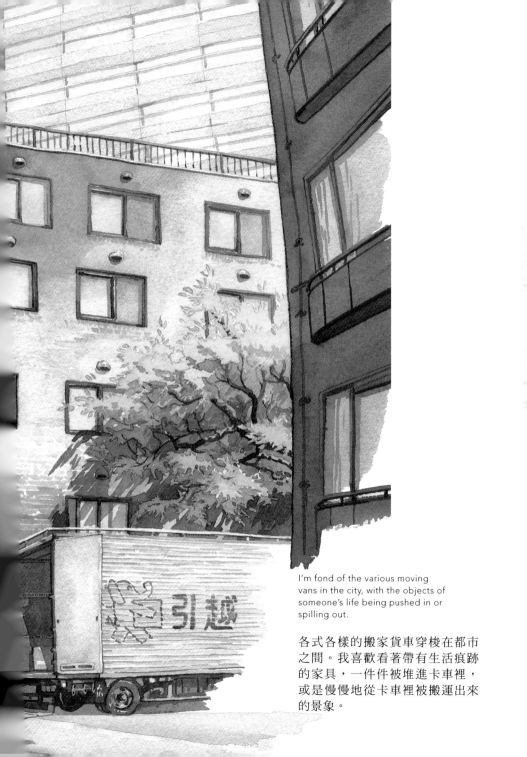

I'm fond of the various moving vans in the city, with the objects of someone's life being pushed in or spilling out.

各式各樣的搬家貨車穿梭在都市之間。我喜歡看著帶有生活痕跡的家具,一件件被堆進卡車裡,或是慢慢地從卡車裡被搬運出來的景象。

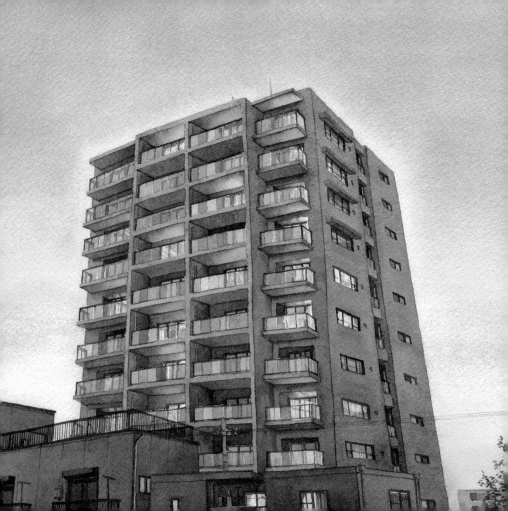

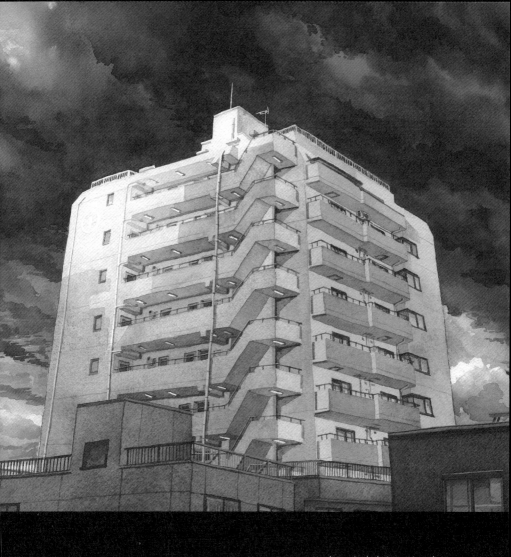

A particularly imposing sky.

令我印象特別深刻的天空。

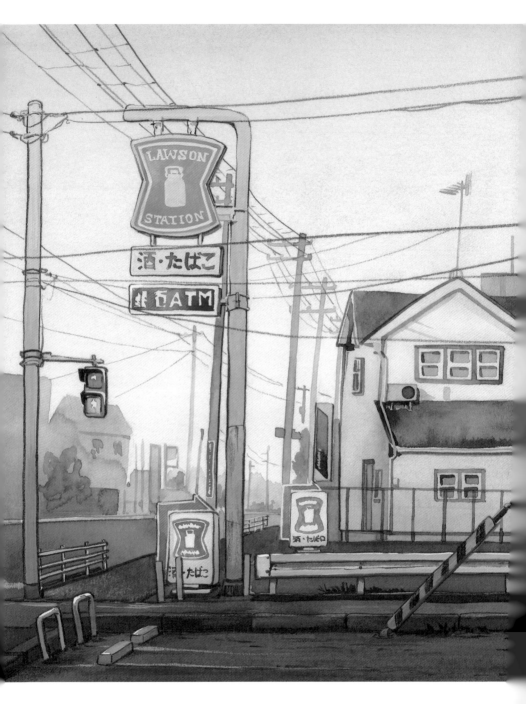

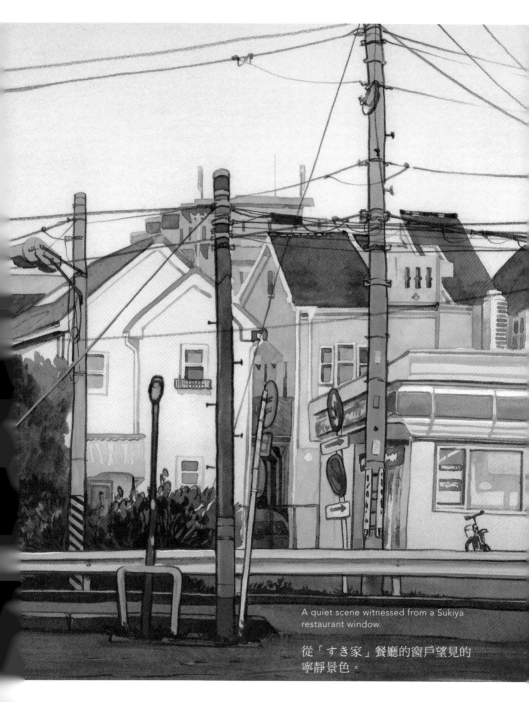

A quiet scene witnessed from a Sukiya restaurant window.

從「すき家」餐廳的窗戶望見的寧靜景色。

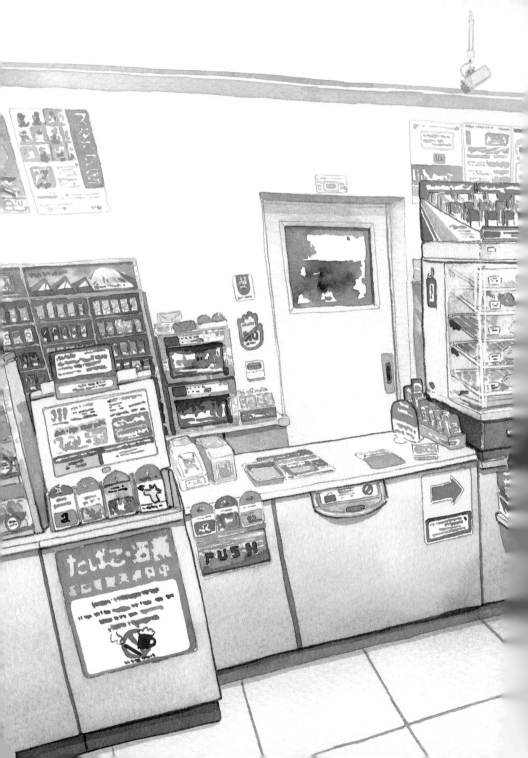

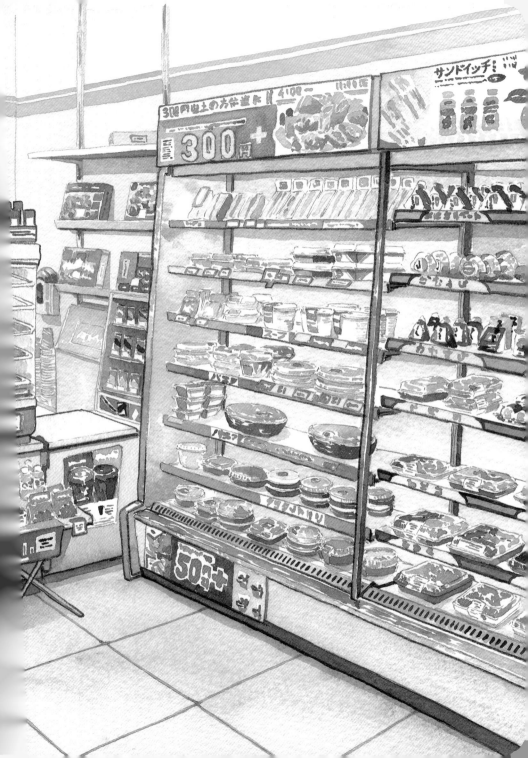

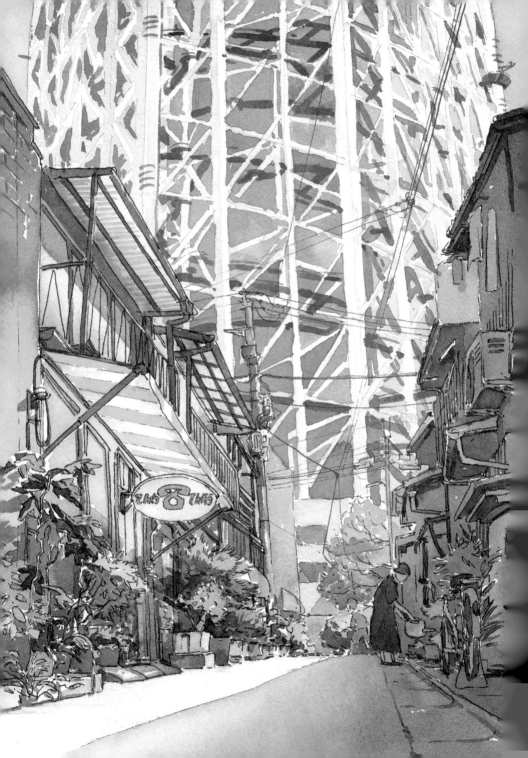

It was a scorching hot afternoon for location-hunting.

某個勘景的炎熱午後。

Sometimes the way buildings interact highlights the absurdity of their differences, like here with the gigantic Tokyo Sky Tree.

有時，建築物會互相影響，它們相會的景象往往襯托出彼此荒誕的差異。就像聳立著巨大晴空塔的此地一樣。

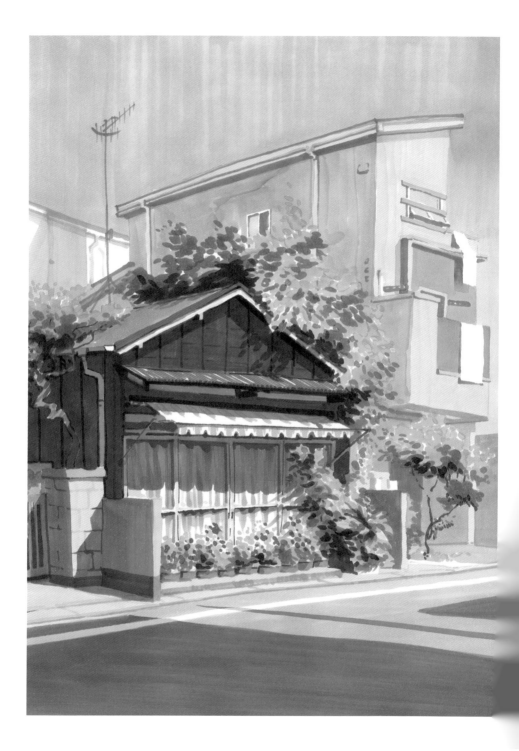

(Right) Our dog fell asleep on my knees while I painted this piece.

（右）在我繪製這幅圖時，愛犬在我的膝上打了個小盹。

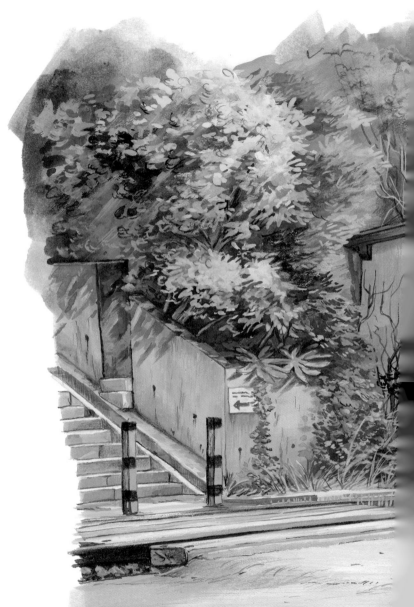

I still wrestle a lot with poster color paints.

我到現在還是和廣告顏料苦苦搏鬥著。

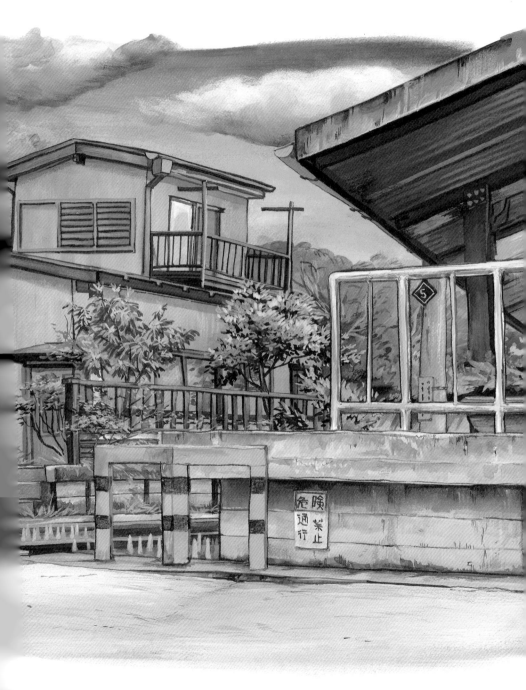

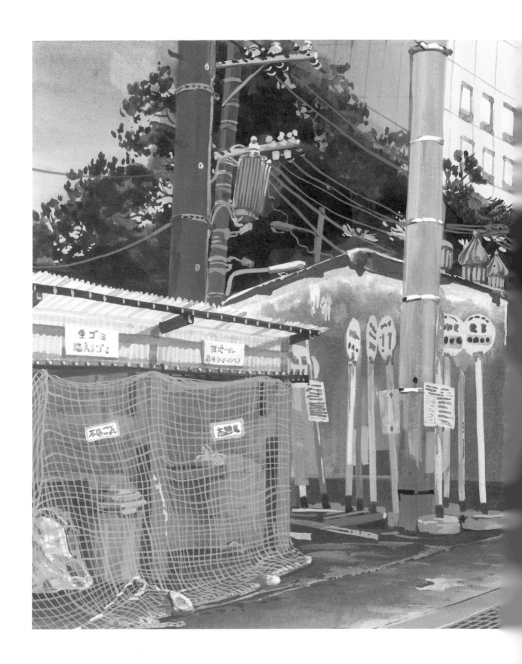

The colors of this bus parking lot were a bit dull and greyish, so I tried to paint on the cardboard backing of a watercolor paper block. The paints soaked through and bled so much that I almost completely gave up on it, but it all came together when I started layering the paint.

我試著在水彩本的封底卡紙上，繪製這幅色調混沌而灰濛濛的巴士停車場。一開始顏料滲透又暈開，讓我幾乎要放棄，不過疊色之後，就不知不覺順利畫好了。

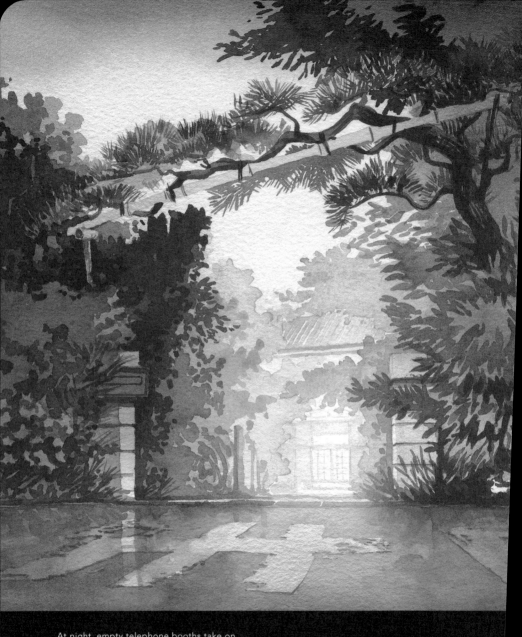

At night, empty telephone booths take on an eerie quality, making them strangely compelling.

夜晚空蕩的電話亭雖然令人發毛，
卻有一股說不上來的魅力。

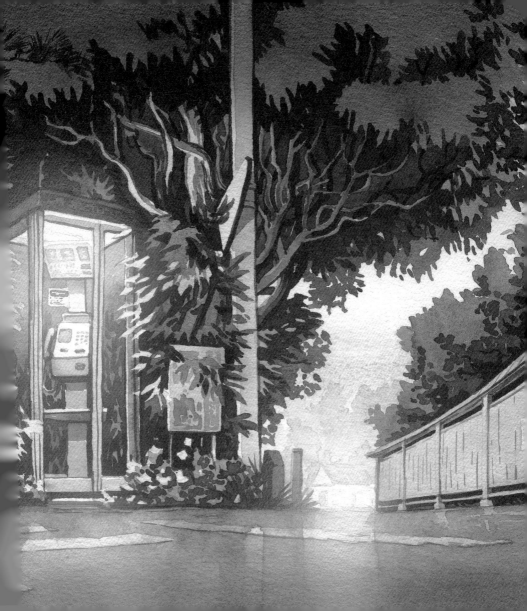

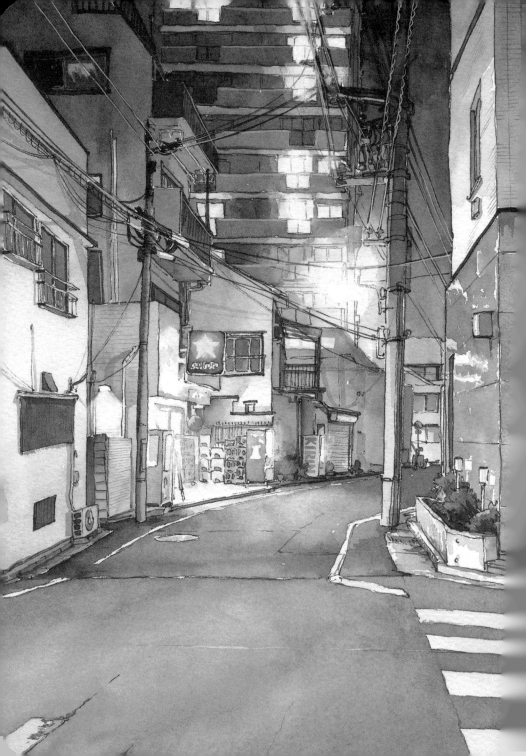

After finishing a day's work, I'd
walk from the animation studio in
Kudanshita to our home in Waseda,
gathering nighttime city scenes along
the way.

結束一天的工作，我習慣從位在九段下的動
畫工作室走回早稻田的住處，沿途蒐集夜晚
的街道風景。

n alcohol shop is open late.

業到很晚的酒類專賣店。

I have a soft spot for hills and
stairs such as these. They can open
up a lot of space in a picture's
composition.

我總是不知不覺地受到小丘或
臺階的吸引。這樣的地方能為
構圖延伸更多的視野。

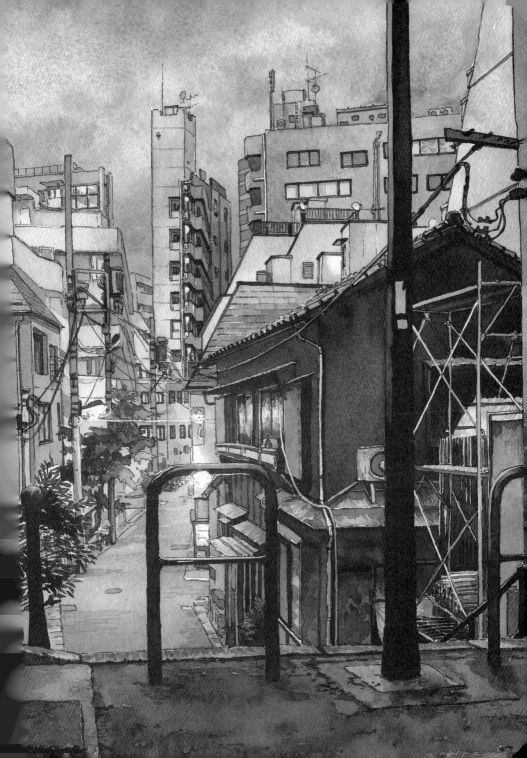

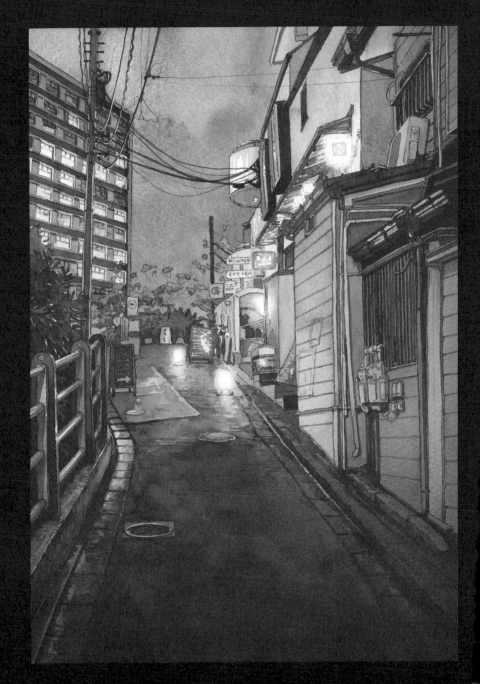

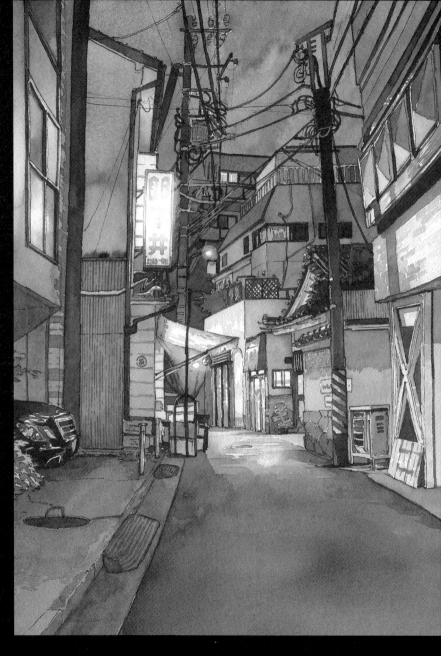

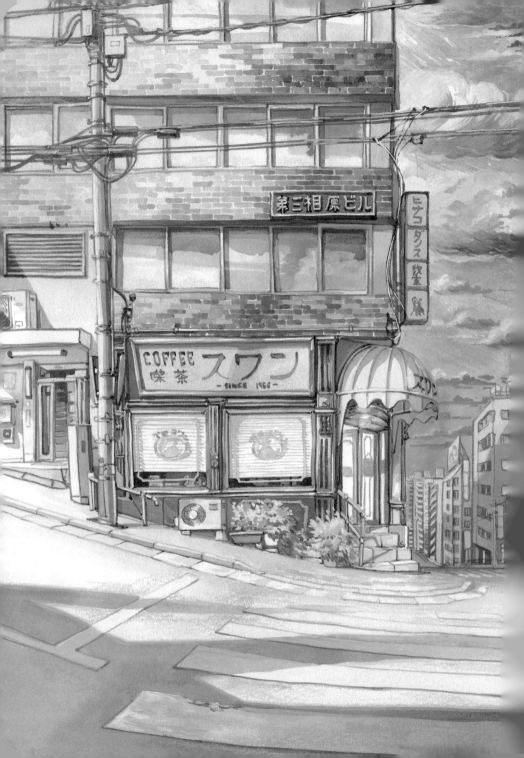

(Left) A street corner background with a made-up cafe for a collaborative piece with Kana.
(Right) A laundry shop I saw somewhere. This was the picture that started me on the whole "Tokyo Storefronts" adventure!

（左）這幅街角的背景圖是我和Kana（作者的妻子）共同製作，圖中有一間虛構的喫茶店。
（右）在某處看見的投幣式洗衣店。這裡正是展開第一本作品《東京老鋪》冒險的原點。

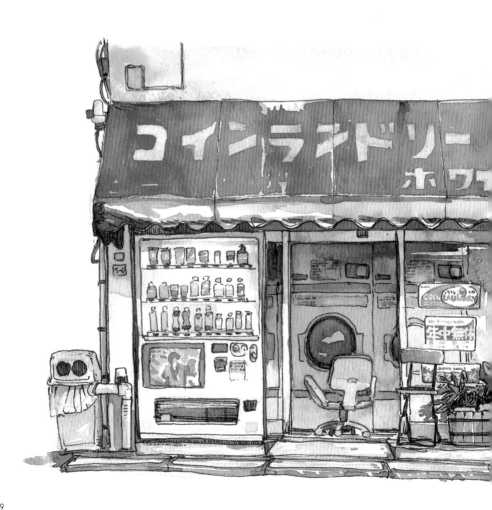

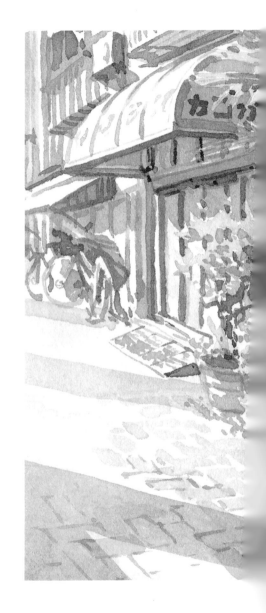

Painting with waterproof color inks is so different from the watercolors I normally use that I always seem to enjoy it – I want to use them more, but I'm afraid I'll grow too accustomed to this frivolous layering. It's so great to put a shadow on top of everything!

相較於我平時使用的水彩顏料，耐水性的彩墨繪製起來感覺完全不同，讓我畫得不亦樂乎。雖想更常使用這個媒材，但好像會不小心就習慣於這種太過輕鬆的疊色方式。可以在任何地方輕輕鬆鬆疊加陰影的感覺真的太過癮了！

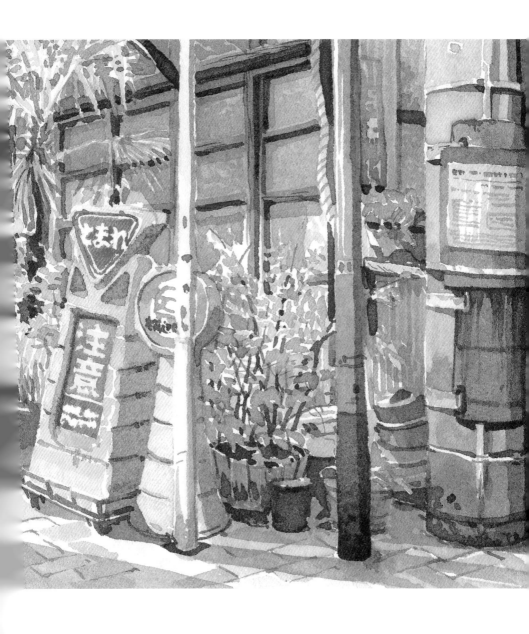

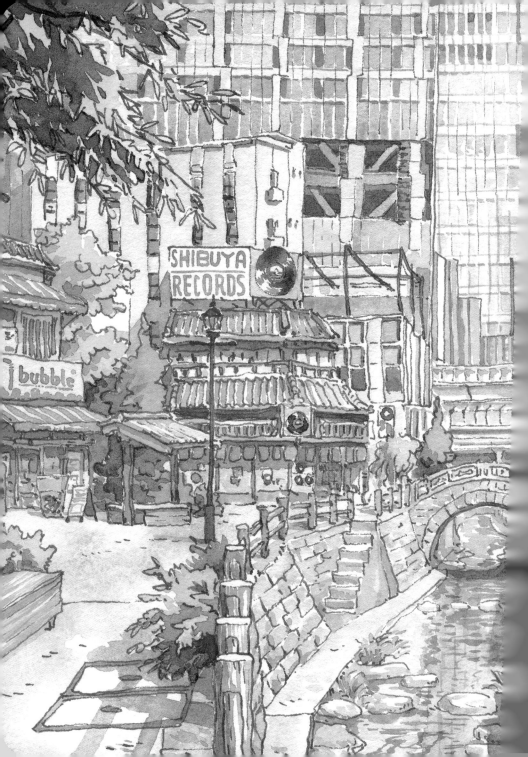

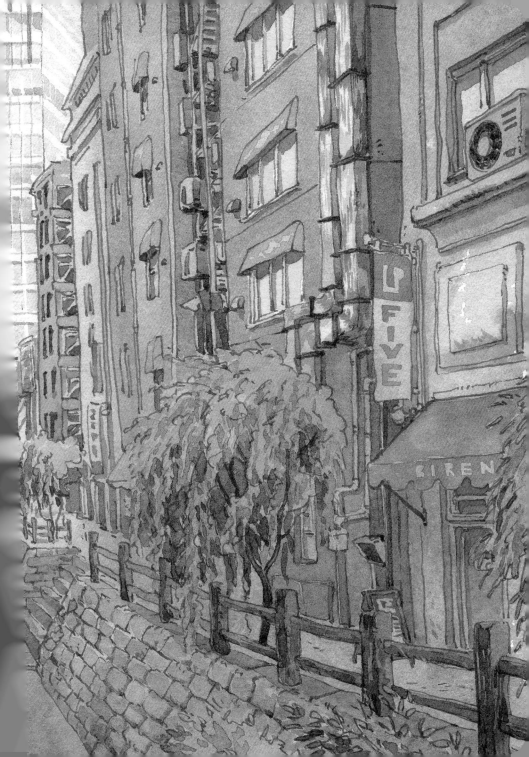

Bridges make for some of the most splendid city spaces, and the contours of an elegant arch can be appealing in itself.

橋梁造就了美好的城鎮風景。優雅的拱形曲線本身就魅力十足。

I really don't get water-soluble pencils at all.

我真的對水性色鉛筆這種東西一點概念也沒有。

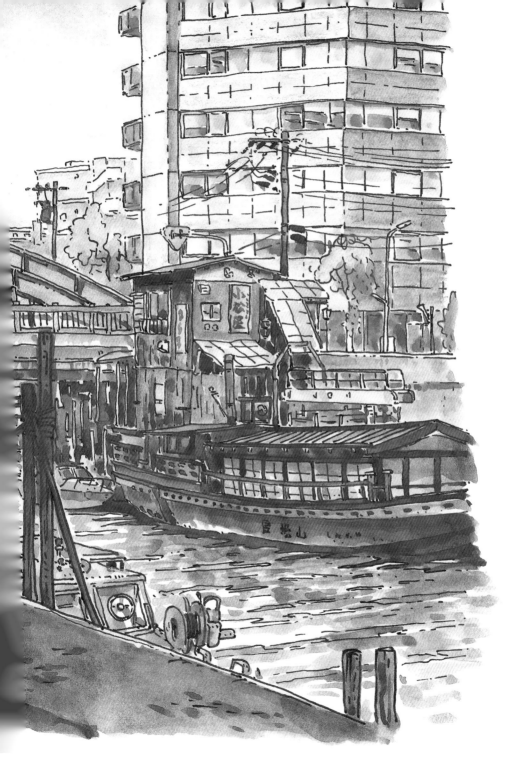

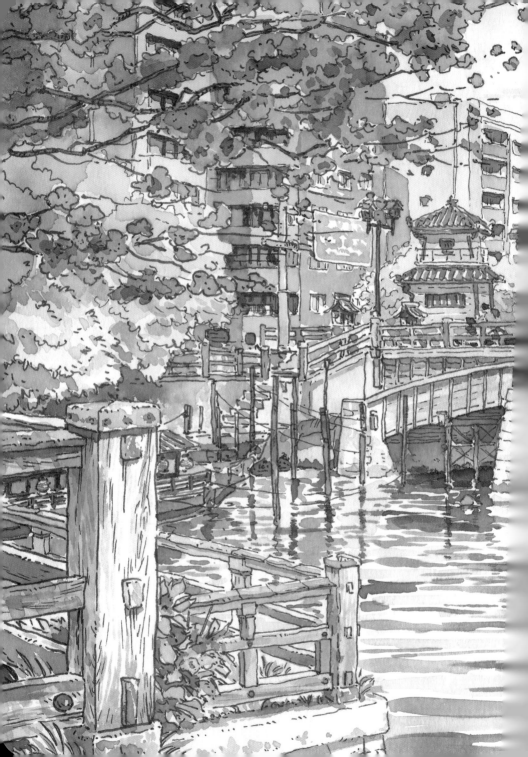

I would love to see more traditional-style wooden bridges over the many canals in Tokyo.

要是東京各處的運河都能看見這種傳統的木橋就好了。

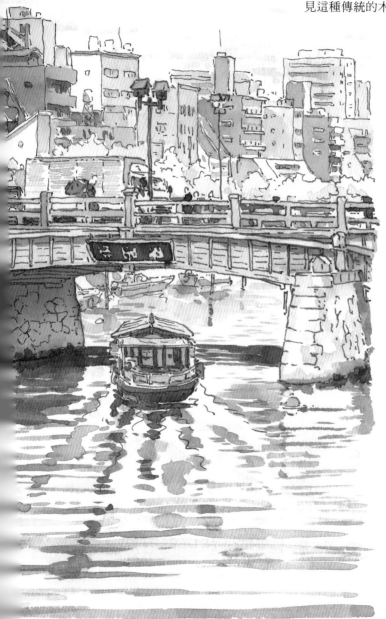

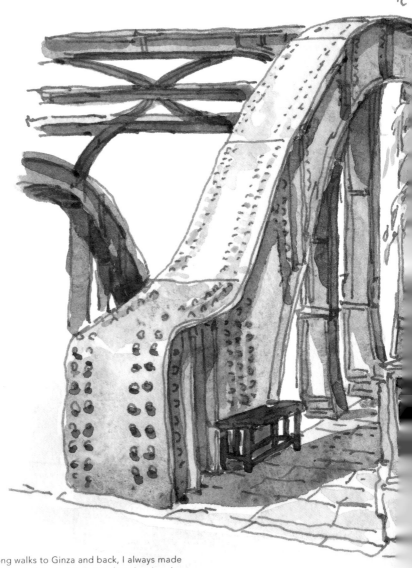

Going on long walks to Ginza and back, I always made sure to go through this spot. I stopped to sketch, take photos or just sit down to rest or read many times.

來回銀座的漫長路途上，這裡可以說是我
的必經之地。我好幾次在這裡停下來速
寫、拍照，或是坐下休息、看看書。

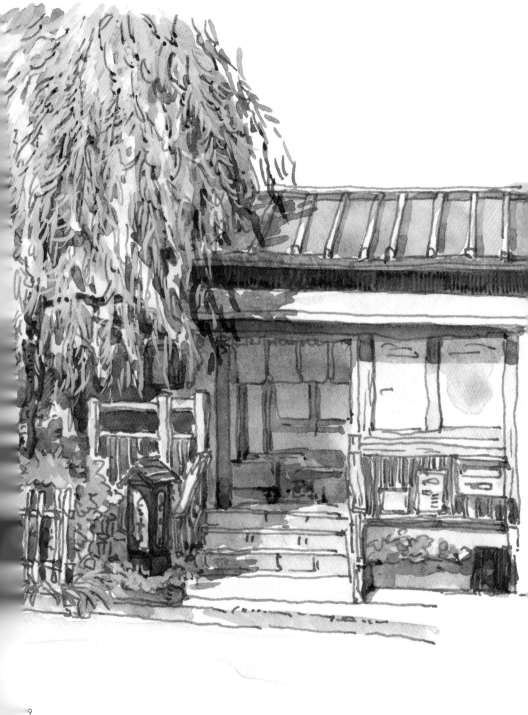

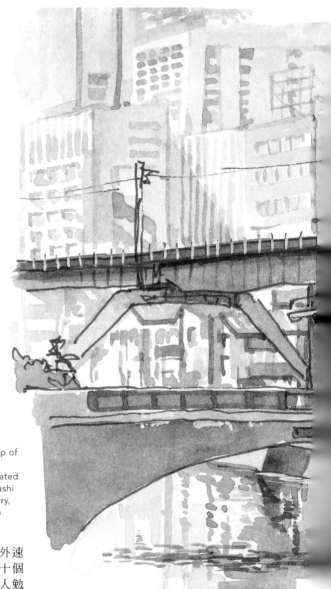

I invited two friends for an outdoor
sketching session, but somehow we
ended up drawing in a bustling group of
almost ten artists!
We squeezed into the restaurant located
underneath what was once Manseibashi
Station to eat that week's special curry,
then walked to Ochanomizu for even
more sketching.

我邀請兩位朋友一起來場戶外速
寫，結果回過神來竟成了近十個
人的藝術家大團體。全部的人勉
強擠進了舊萬世橋的餐廳，吃了
每週特餐的咖哩後，前往御茶水
繼續寫生。

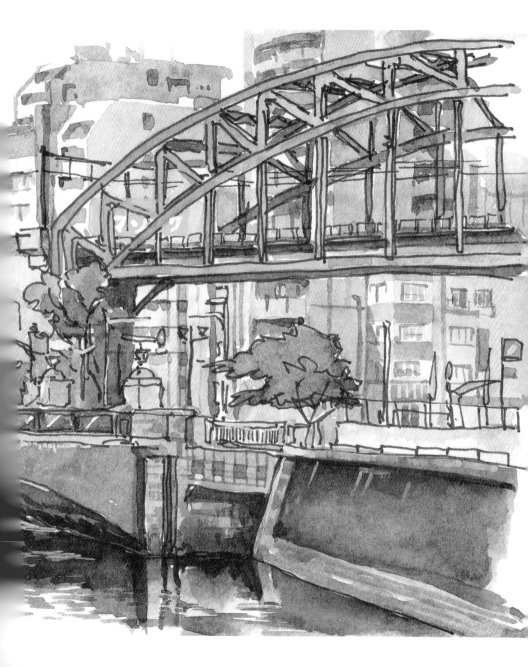

1

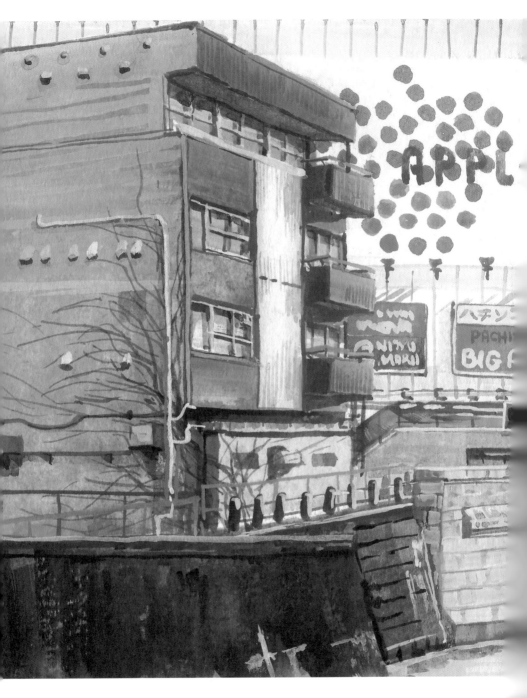

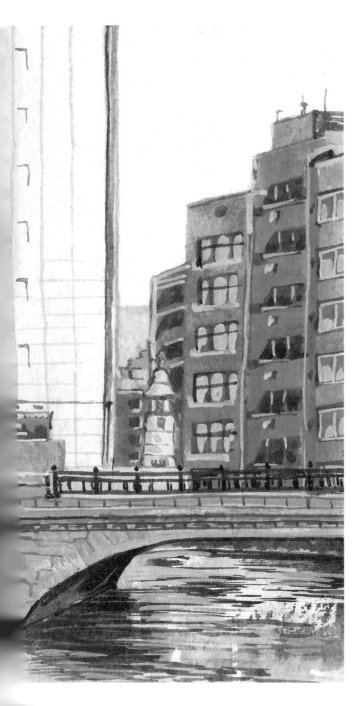

I'm happy with the contrast in colors, but I should have painted it in a wider angle.

我很滿意顏色對比的
表現。不過，構圖的
角度應該再廣一點。

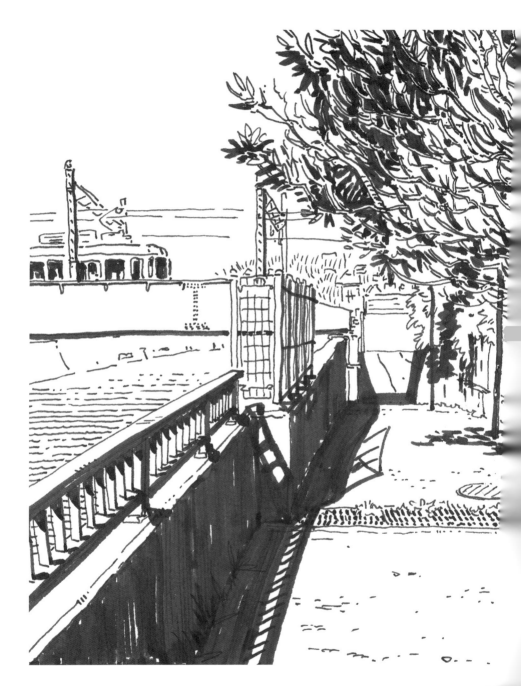

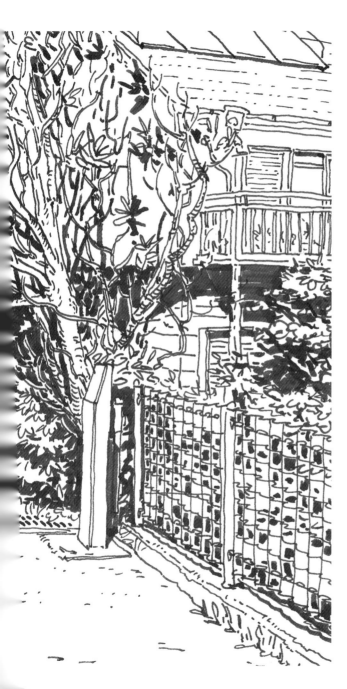

The Enoden train line crossing a river near a station. I'm walking back home.

車站附近橫越河川的
江之電鐵路。在我步
行回家的路上。

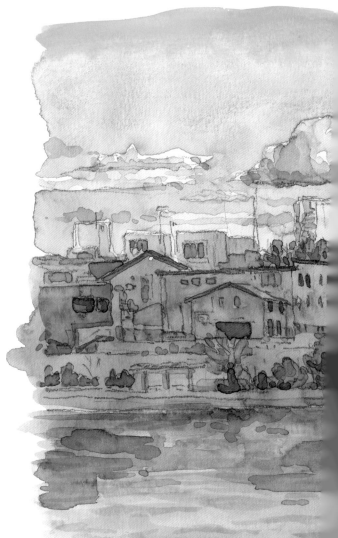

I caught this sunset while walking our dog along the Sumida River. The dark and wet orange pigment edge on the clouds turned out nicely, I think – I really have to use more water and learn to harness this effect!

跟愛犬在隅田川岸邊散步時看見的夕陽。用溼畫法繪製的暗橘色雲朵，邊緣畫得還不錯。我真該多研究這種運用水分去表現的技法。

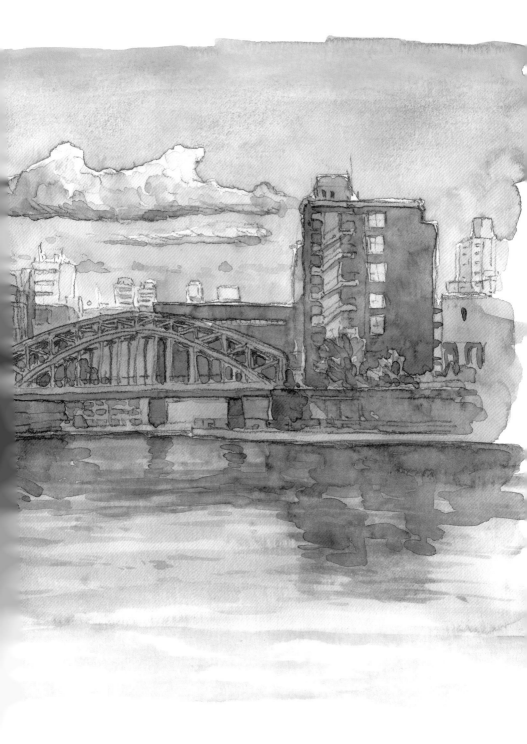

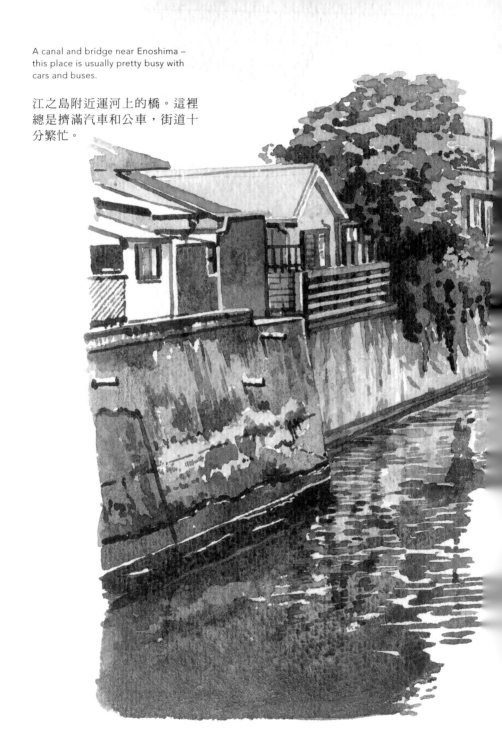

A canal and bridge near Enoshima –
this place is usually pretty busy with
cars and buses.

江之島附近運河上的橋。這裡
總是擠滿汽車和公車，街道十
分繁忙。

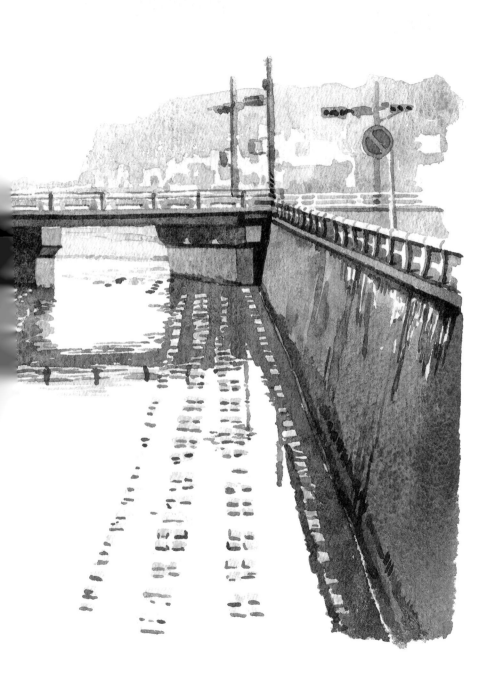

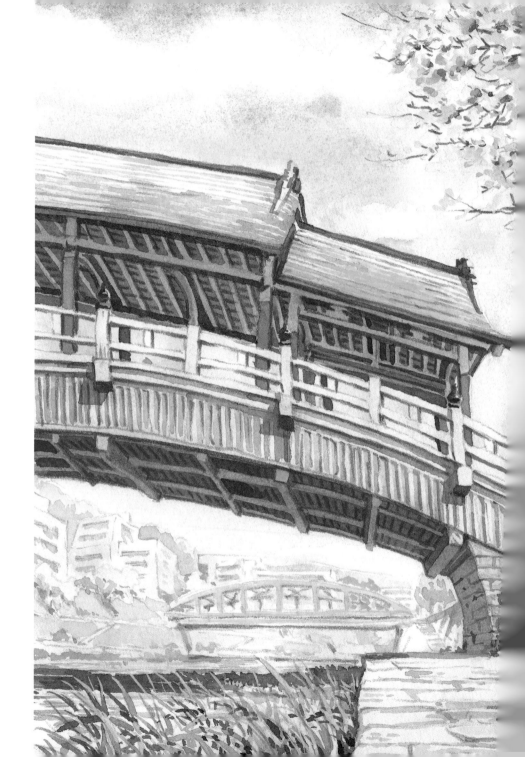

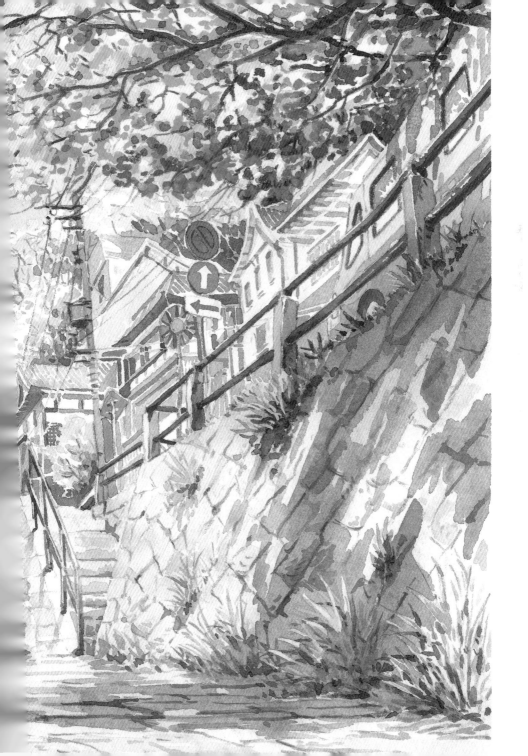

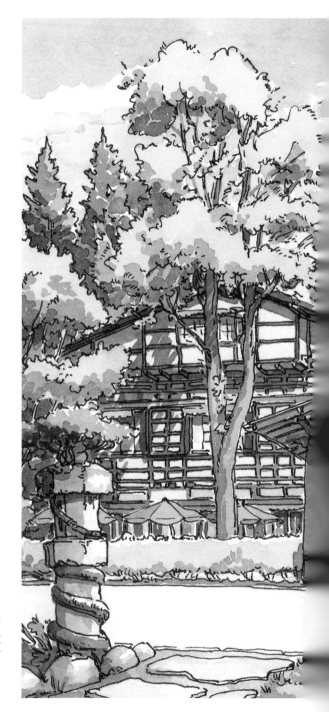

This hotel with a long history inspired an animated movie we love, so of course we had to go and explore.

我們最喜歡的動畫電影，曾受到這間歷史悠久的旅館啟發。所以來到這兒，我們當然得到處探險一番。

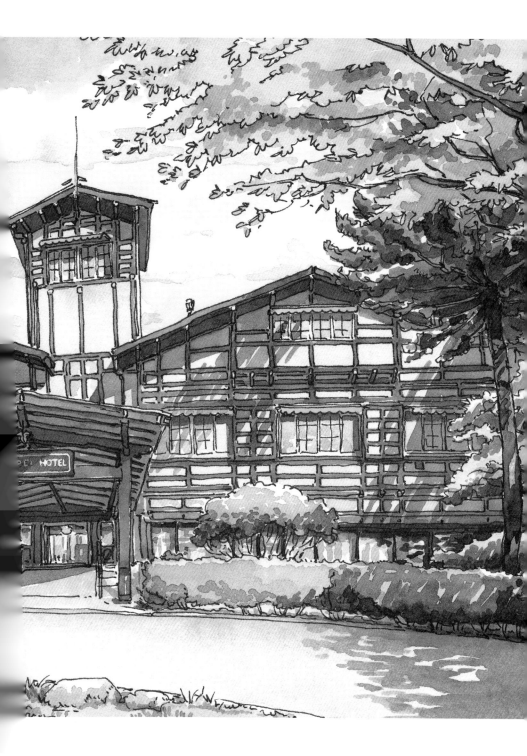

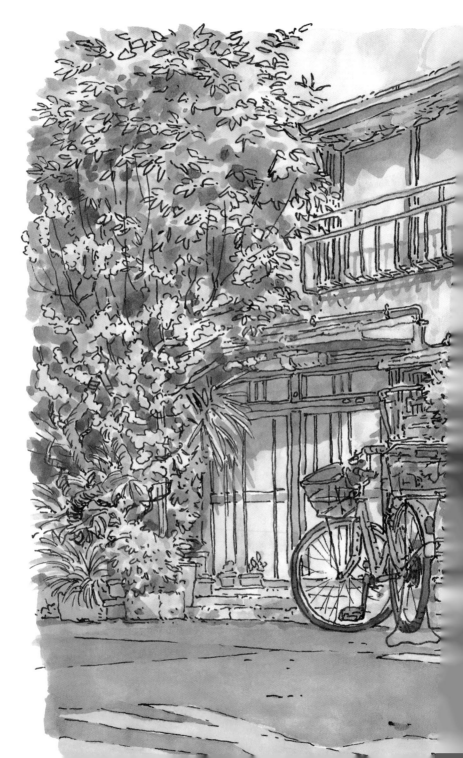

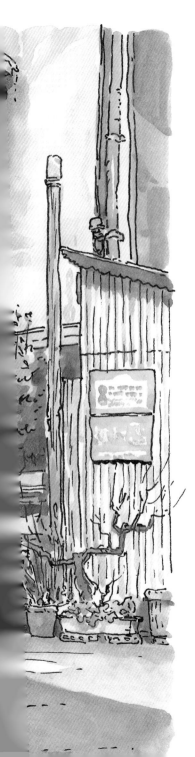

The light watercolor washes turned out well, though this thin paper was not meant to take such abuse.

這幅以溼畫法繪製的淡彩終於順利完成了。但是這種薄透的紙其實不適合這種畫法。

Leaving spaces unpainted and letting the white of the paper shine through can be very important, but I always end up getting overzealous and paint too much!

適時留白，讓紙張呼吸非常重要。但我總是不小心畫過頭，把畫面塗得太滿。

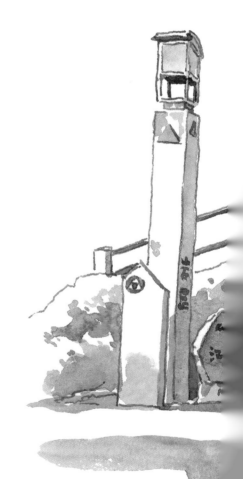

Painting on location can be difficult on its own, and being filmed while doing it is even more stressful. I painted some Japanese letters backwards by mistake and then fixed them at home, but it's all on tape now.

在現場畫畫已經不容易了，再加上被採訪拍照就更加有壓力。那時我把日文字畫反了，只好回家改正，不過當下卻被拍個正著並且播出了。

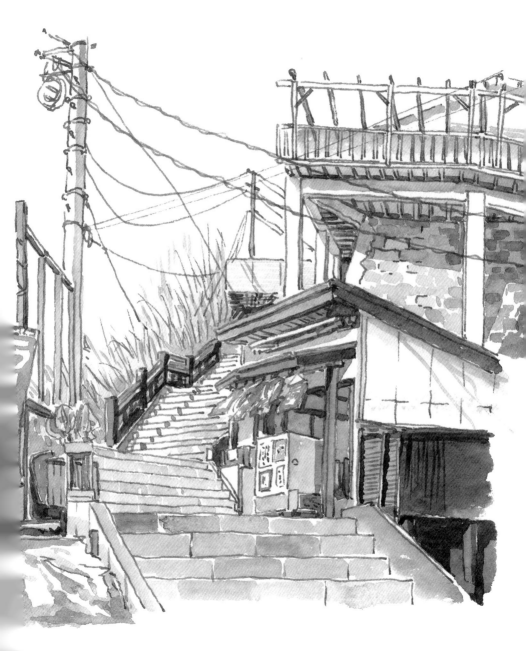

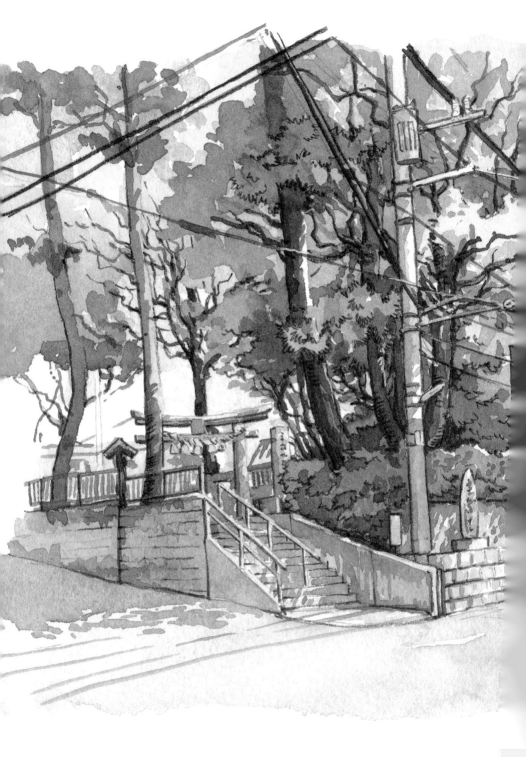

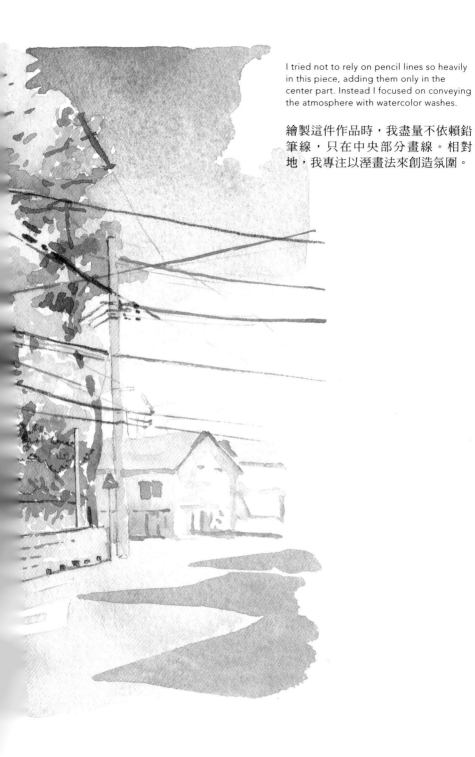

I tried not to rely on pencil lines so heavily in this piece, adding them only in the center part. Instead I focused on conveying the atmosphere with watercolor washes.

繪製這件作品時，我盡量不依賴鉛筆線，只在中央部分畫線。相對地，我專注以溼畫法來創造氛圍。

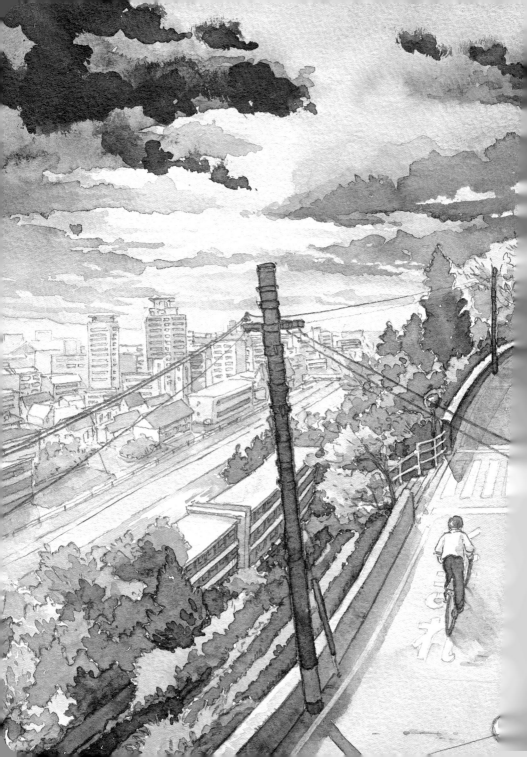

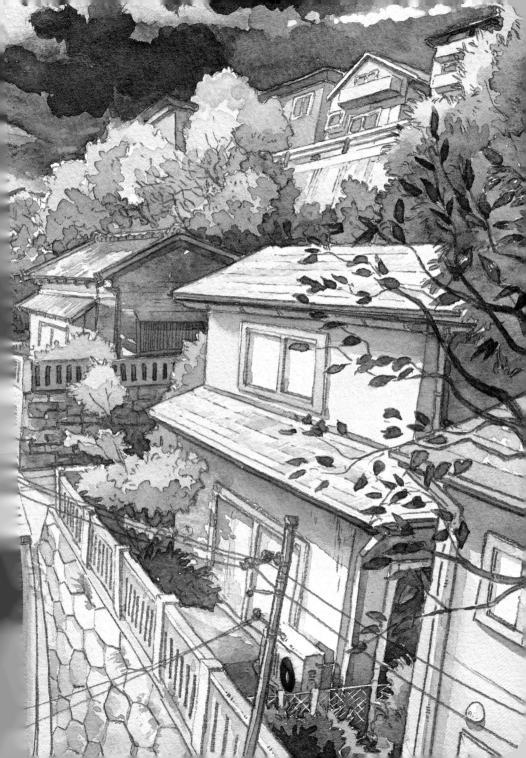

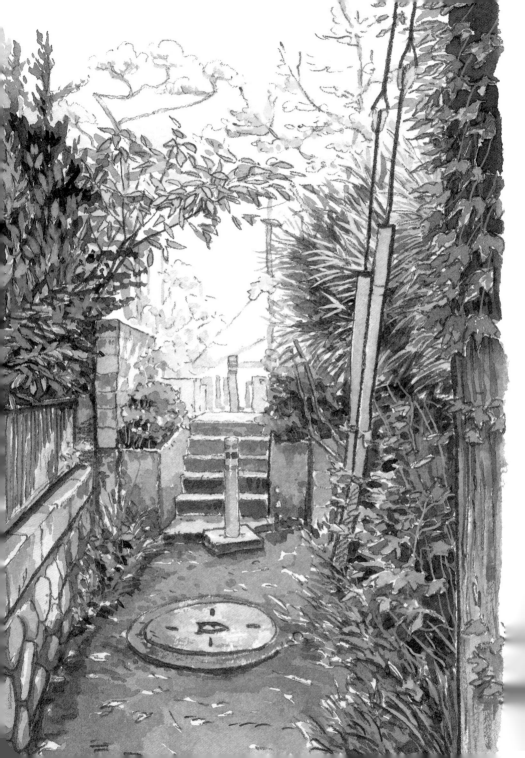

The light was in the perfect position. I wish
I could have captured the highlights better.

就在一瞬間，透進來的光線完美
無瑕。要是這幅畫能更妥善地表
現出亮部就好了。

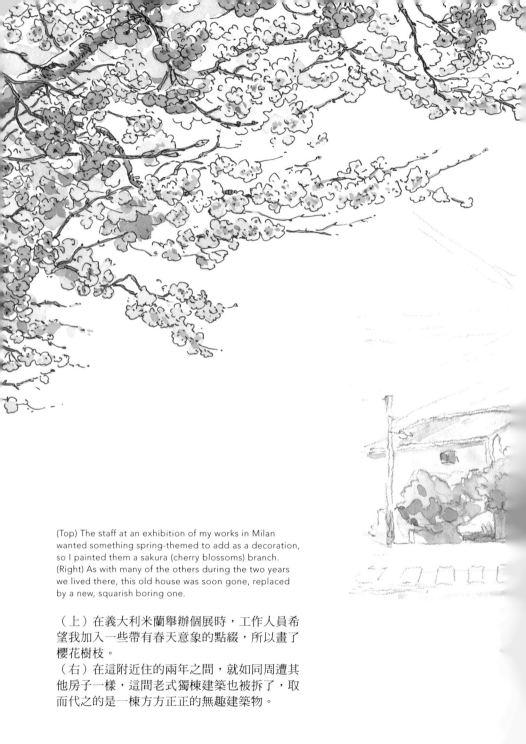

(Top) The staff at an exhibition of my works in Milan wanted something spring-themed to add as a decoration, so I painted them a sakura (cherry blossoms) branch.
(Right) As with many of the others during the two years we lived there, this old house was soon gone, replaced by a new, squarish boring one.

（上）在義大利米蘭舉辦個展時，工作人員希望我加入一些帶有春天意象的點綴，所以畫了櫻花樹枝。
（右）在這附近住的兩年之間，就如同周遭其他房子一樣，這間老式獨棟建築也被拆了，取而代之的是一棟方方正正的無趣建築物。

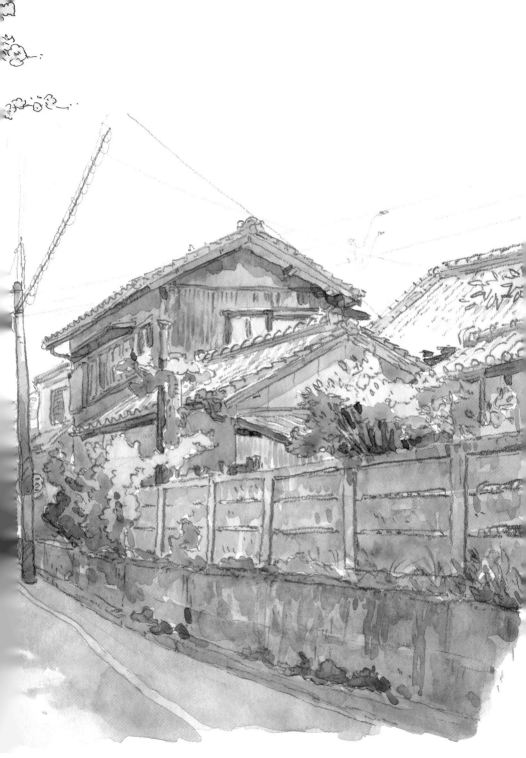

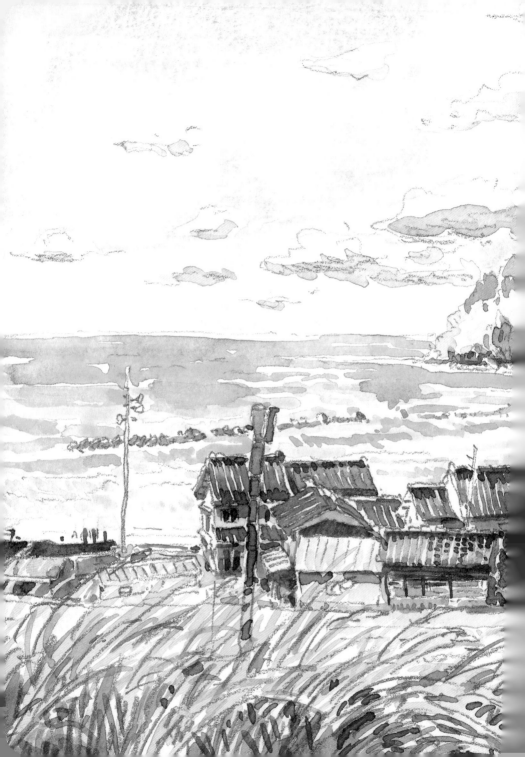

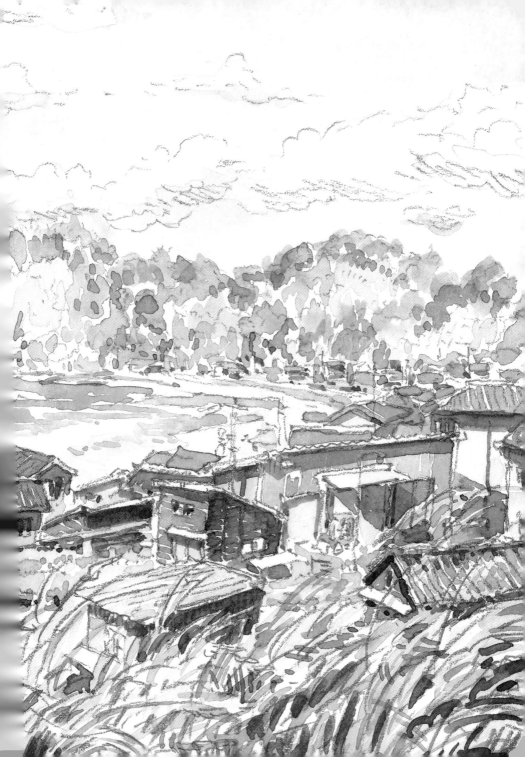

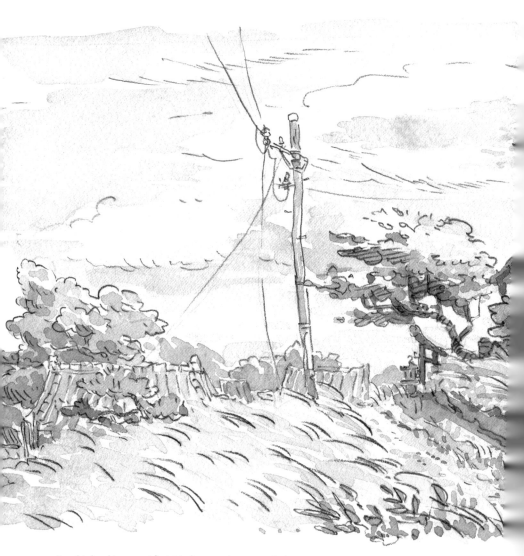

For this book's cover, I first tried an evening scene to try
to show the insides of the "kura" (storehouse) lit up.

這本書的封面我一開始畫的是傍晚景色，想表
現出日式倉庫（くら）裡亮著燈光的情景。

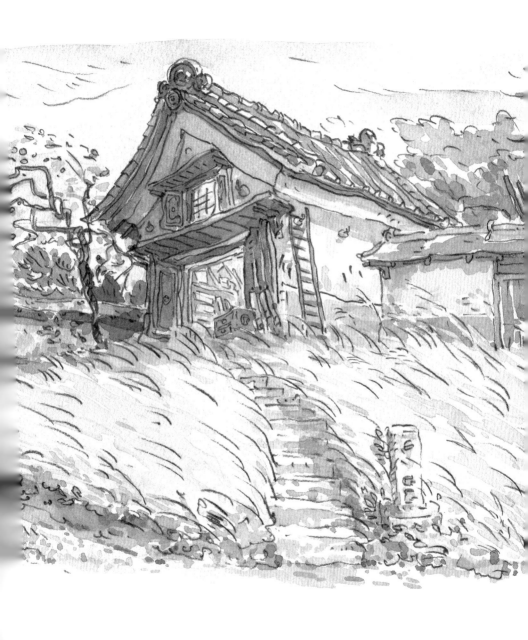

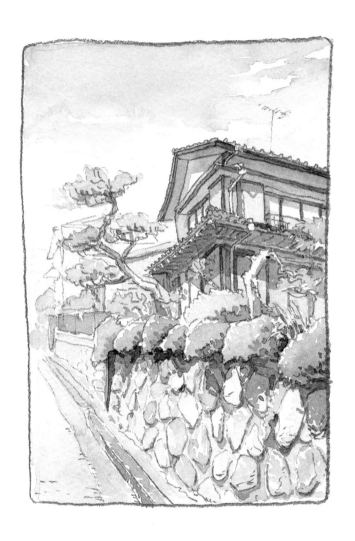

I rarely use such rough-textured paper
– this looks so "watercolor-y!"

我很少使用這種粗糙質地的紙張。
這幅畫的感覺非常「水彩風」。

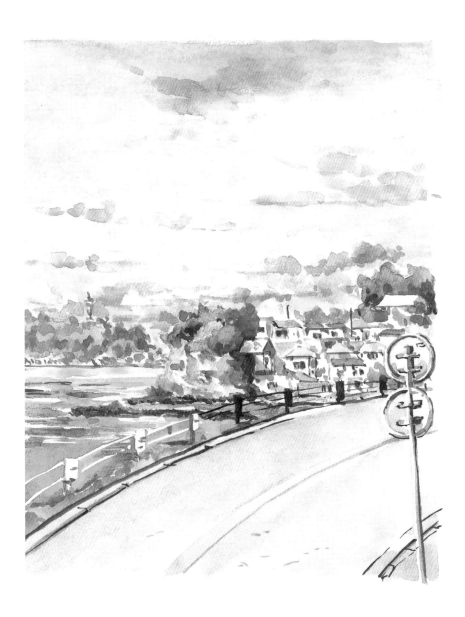

I wish I had gone to explore Enoshima more
when we lived close-by, but we often put off
visiting nearby scenic places and then regret it.

真希望以前住在江之島附近時，有在當地多走走逛
逛。我們常會忽略離自己很近的風景名勝，事後才
感到遺憾。

I have almost no experience drawing
animals, and even simple cats can test my
limits.

我很少畫動物。光是這幾隻小
貓，便能看出我的極限。

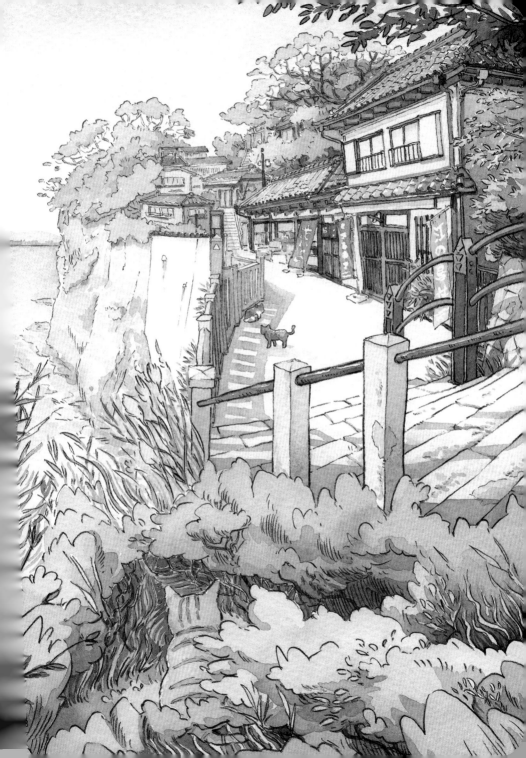

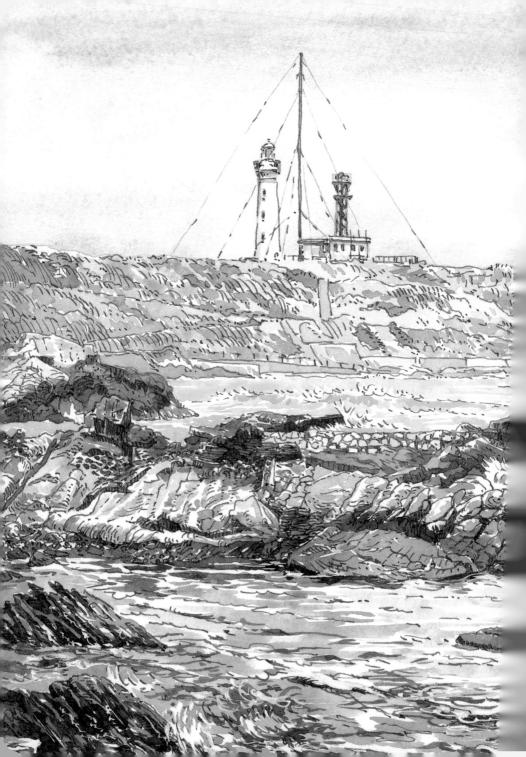

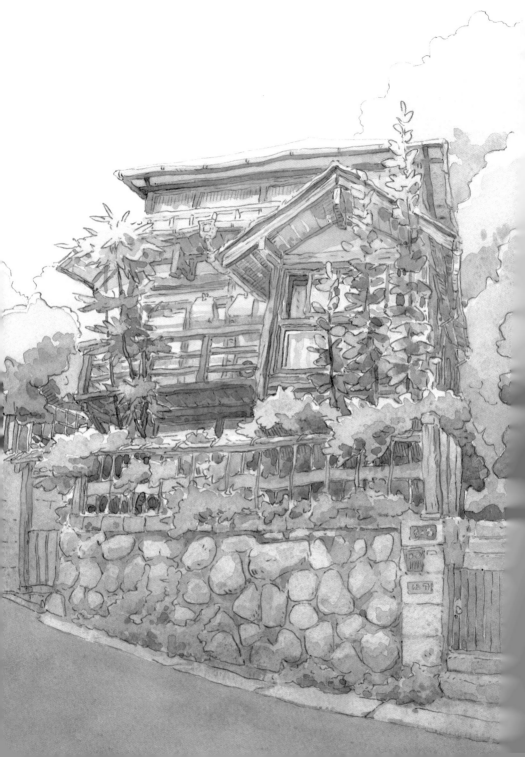

I'm always on the lookout for some interesting-looking detached houses in the suburban neighborhood we currently live in. Sadly, these seem to be a disappearing species.

我總是在居住的近郊住宅區中，尋找有趣的獨棟屋子。可惜的是，這種有特色的建築已經快要絕跡了。

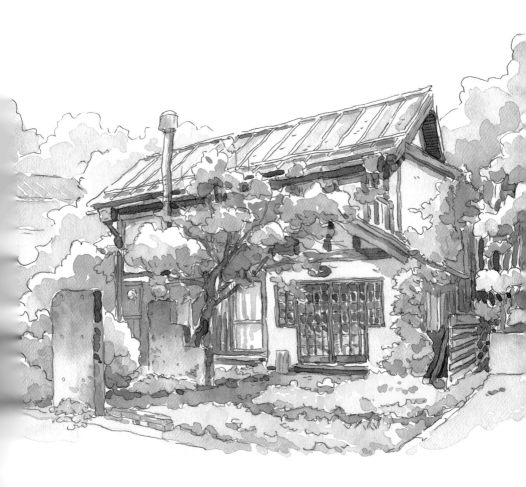

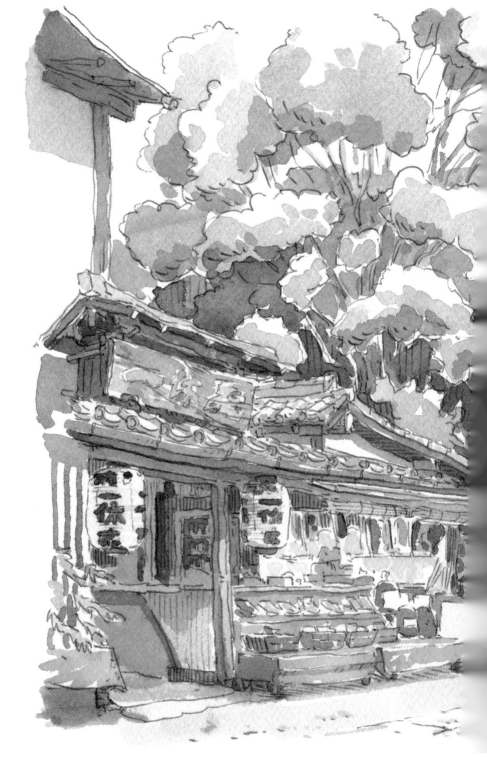

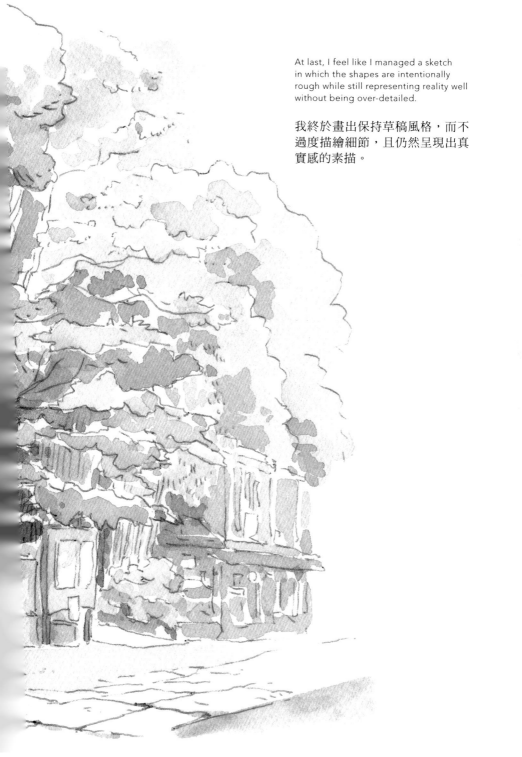

At last, I feel like I managed a sketch
in which the shapes are intentionally
rough while still representing reality well
without being over-detailed.

我終於畫出保持草稿風格，而不
過度描繪細節，且仍然呈現出真
實感的素描。

We came here early in the morning when the restaurant had just opened, and had great soba noodles (the thick type) and shared a plate of tempura. It's been sweltering during the day, and the rainy season is creeping in, too. (May 2022)

一大早來到這，店家也剛開始營業。我們一起吃了美味的蕎麥麵（麵條比較粗的鄉村蕎麥）和一盤天婦羅。中午熱氣逼人，能感覺到梅雨季節快要來了。（2022年5月）

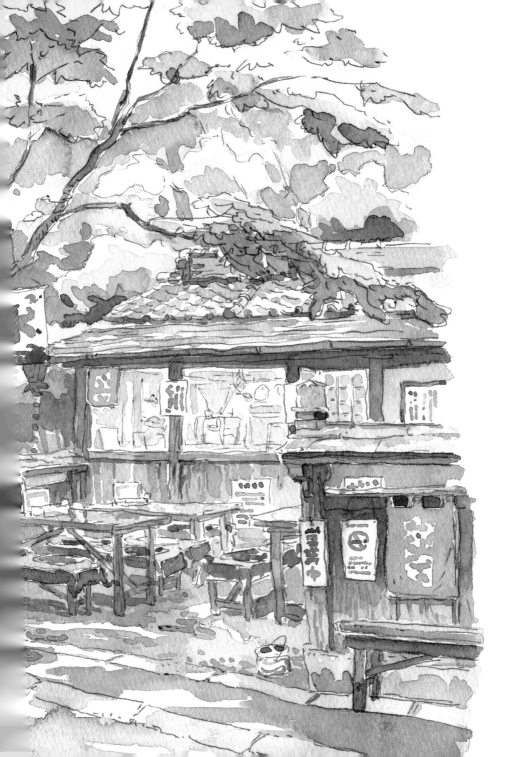

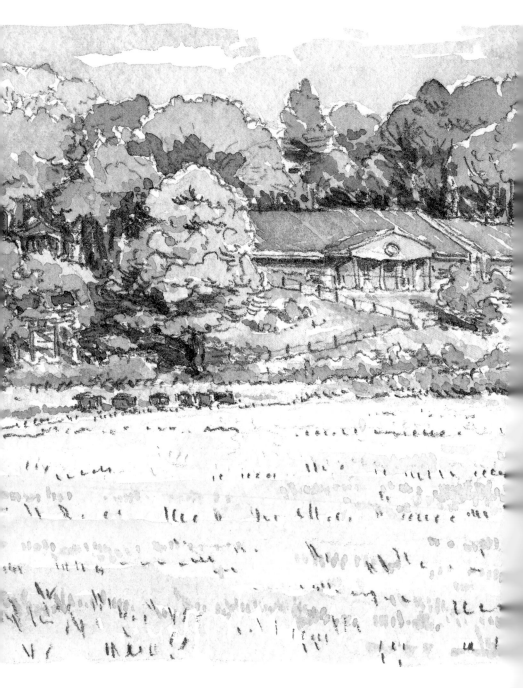

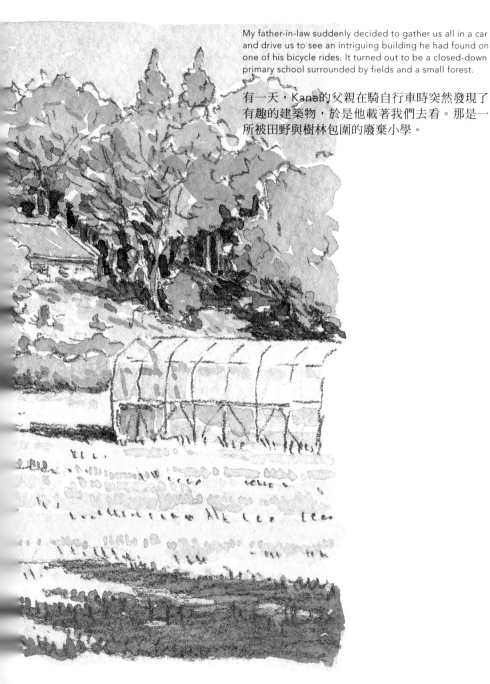

My father-in-law suddenly decided to gather us all in a car and drive us to see an intriguing building he had found on one of his bicycle rides. It turned out to be a closed-down primary school surrounded by fields and a small forest.

有一天，Kana的父親在騎自行車時突然發現了有趣的建築物，於是他載著我們去看。那是一所被田野與樹林包圍的廢棄小學。

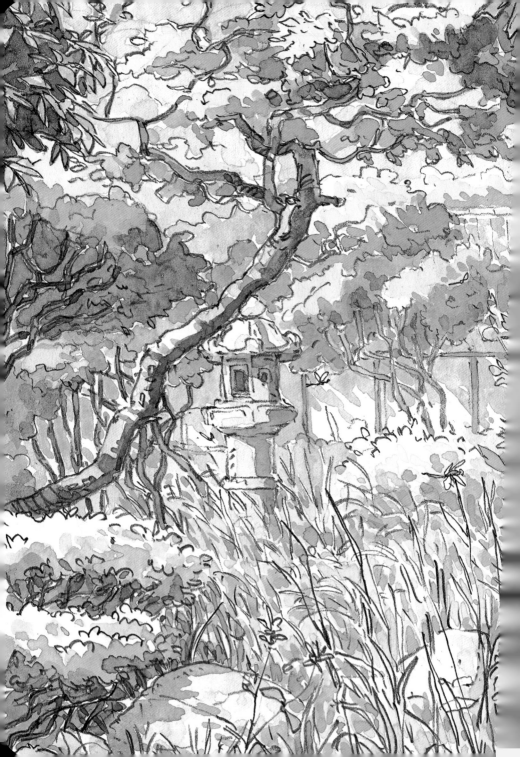

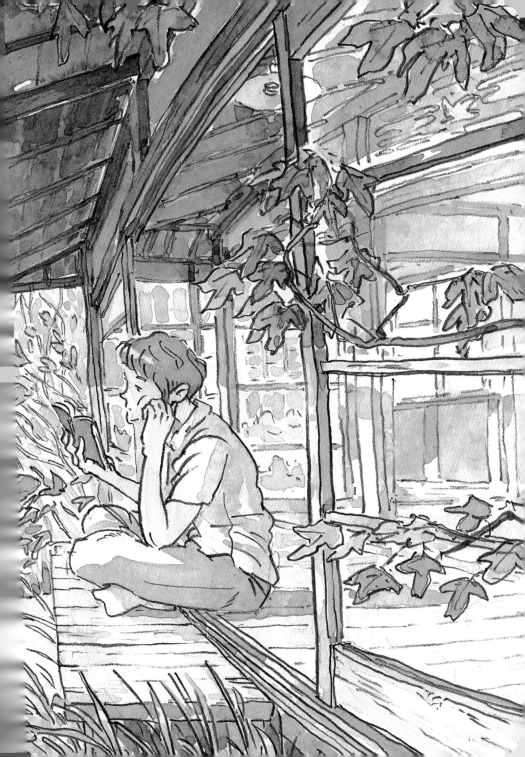

I once saw a room like this in an old house
that had been converted into a museum,
but as is so often the case in such places, it
was totally empty. I tried to breathe some
life into it.

我以前在一個舊民房改建的博物
館裡看過這樣的房間。但是這些
地方總是空蕩蕩的。在畫這幅畫
時，我試著帶入一些生活氣息。

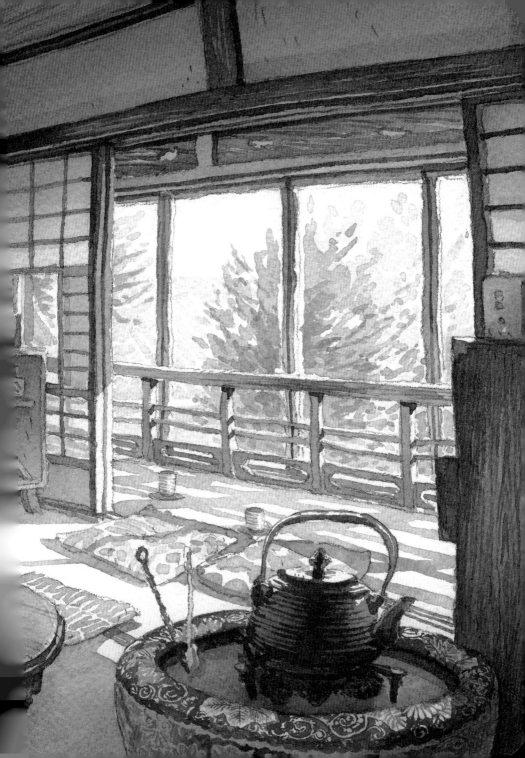

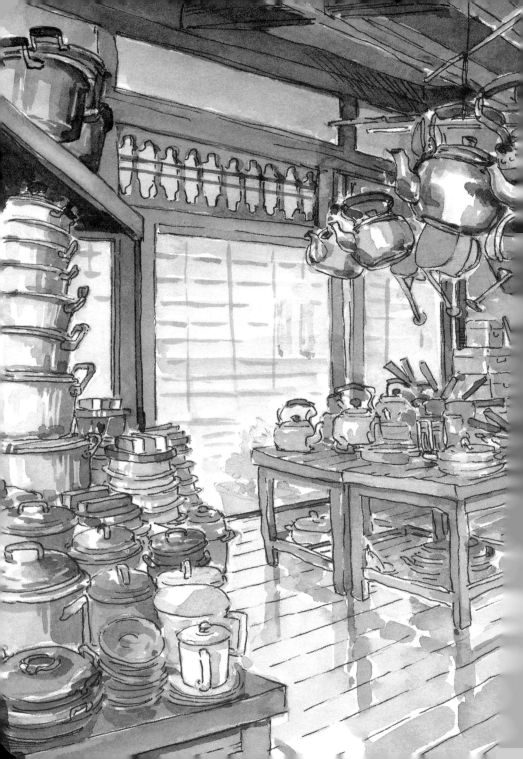

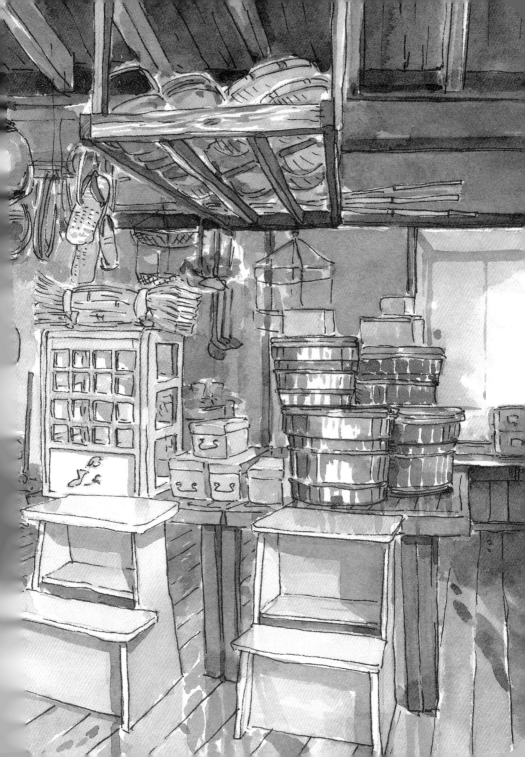

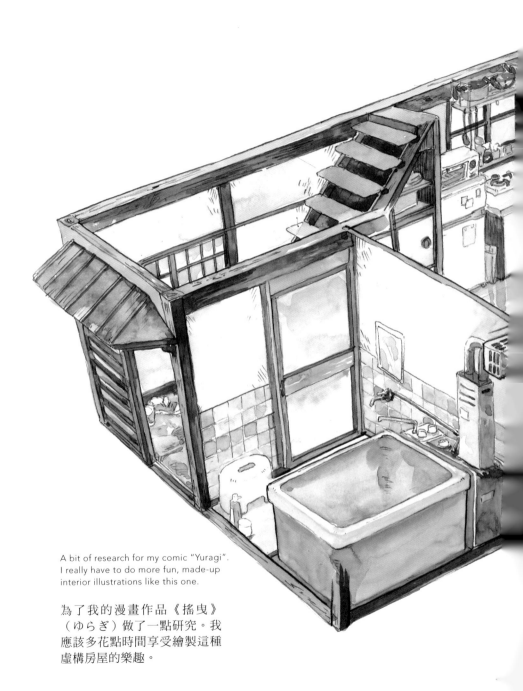

A bit of research for my comic "Yuragi".
I really have to do more fun, made-up
interior illustrations like this one.

為了我的漫畫作品《搖曳》
（ゆらぎ）做了一點研究。我
應該多花點時間享受繪製這種
虛構房屋的樂趣。

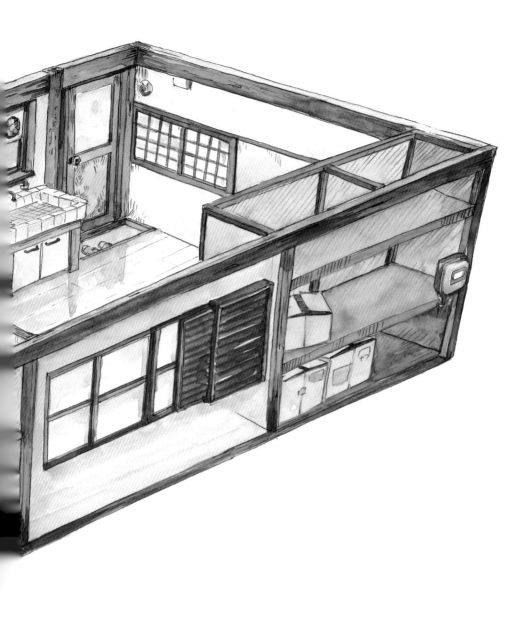

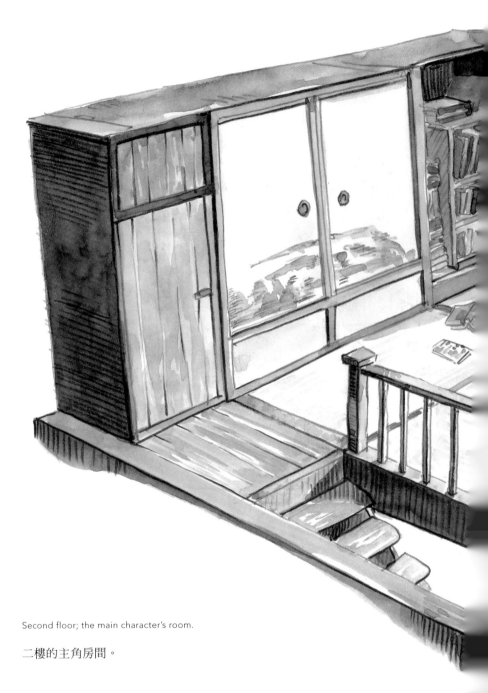

Second floor; the main character's room.

二樓的主角房間。

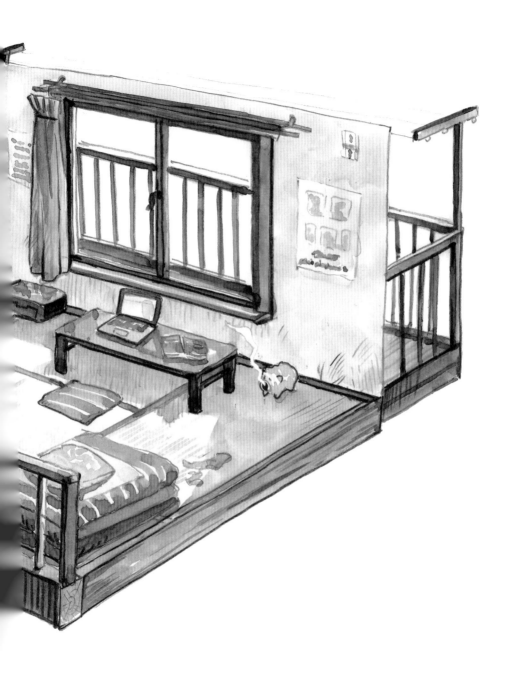

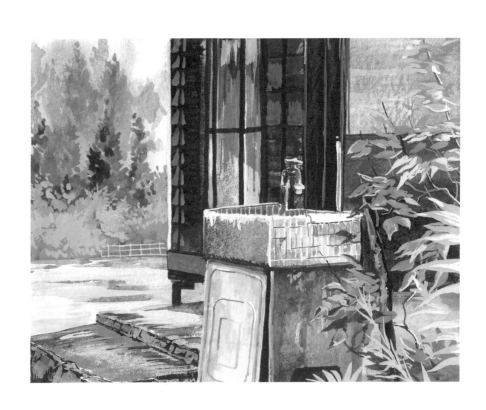

Someone must have been proud of this tiled
sink maybe fifty or sixty years ago. Objects like
this have me leaning towards the sad side of
nostalgia, yet I seek them out in the buildings
and places I paint.

遙想五、六十年前，應該有人對這個鋪
了瓷磚的流理臺感到自豪吧。我會在繪
製的場景和建築物裡，尋求一種帶有哀
愁，讓人心裡有點酸酸的感覺。

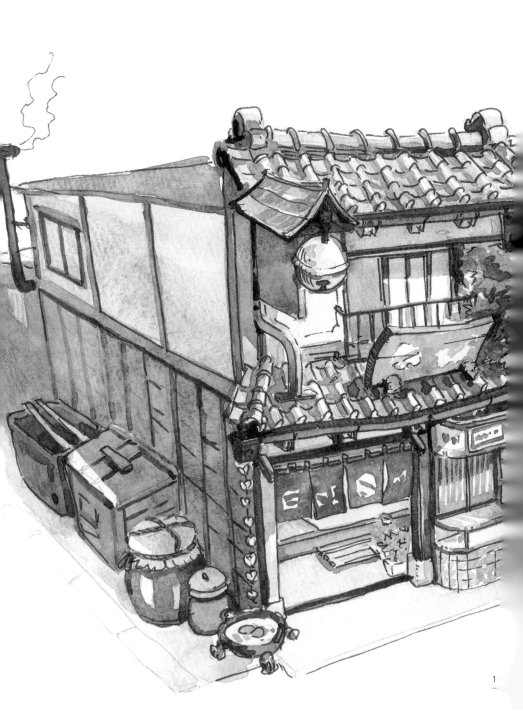

So many details to decide on!
Making up fantastic but realistic-
looking buildings and places
requires so much research!

這張畫裡有一堆要決定的細節。為了畫
出幻想與真實兼具的建築物和場所,需
要做很多研究!

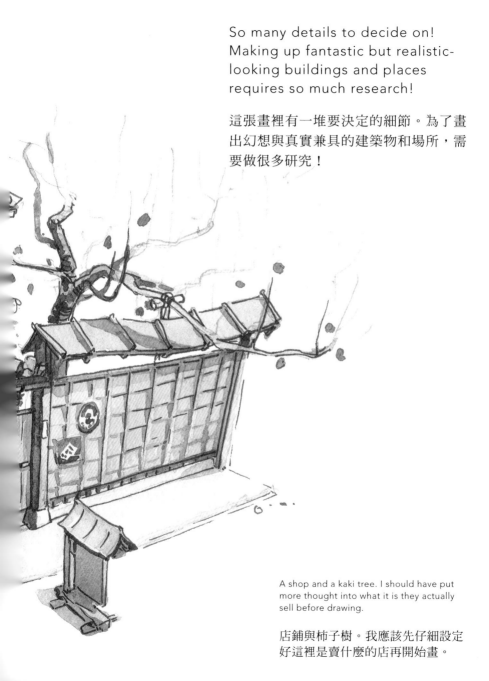

A shop and a kaki tree. I should have put
more thought into what it is they actually
sell before drawing.

店鋪與柿子樹。我應該先仔細設定
好這裡是賣什麼的店再開始畫。

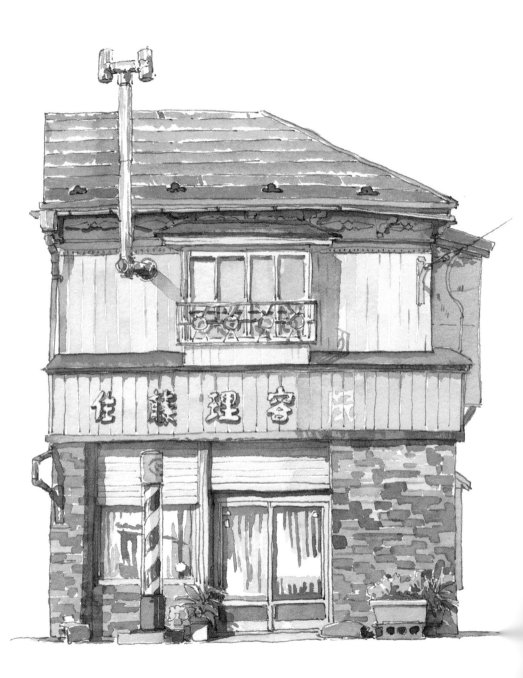

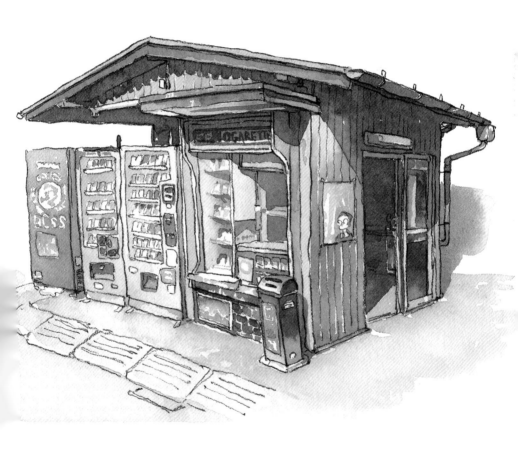

Old local election posters are often stuck to buildings here and there. I don't want to paint them as they are, so I usually just put in a random, made-up face.

日本的建築物常常貼著選舉的舊海報，但不能直接畫，所以我總是畫些虛構的叔叔臉。

The side view offers a bit more visually compared to just a flat front, but I still like how iconic and design-like the storefront pictures look.

畫入側面時，與只畫了正面的畫相比，建築物顯得更像樣了。不過話說回來，我還是喜歡富象徵性且具有設計感的店鋪正面。

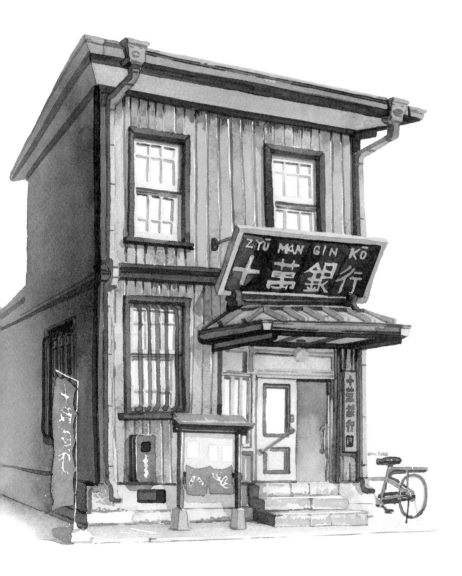

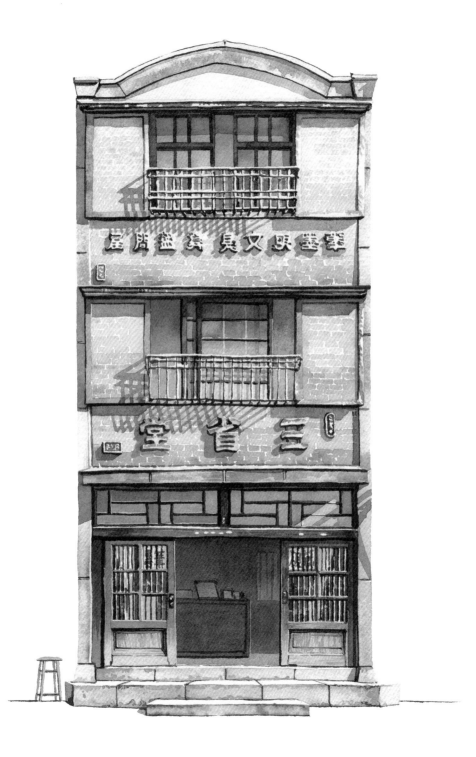

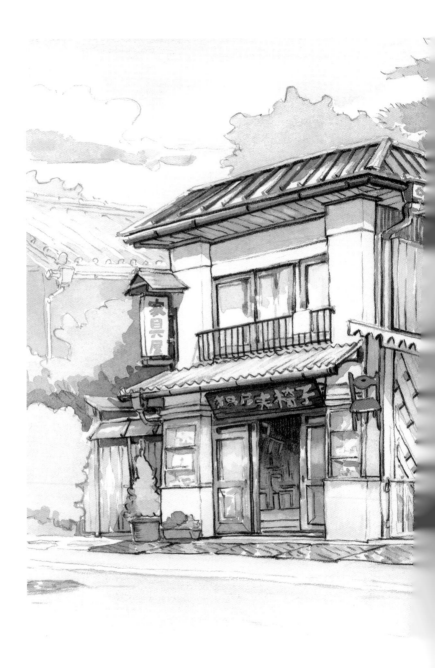

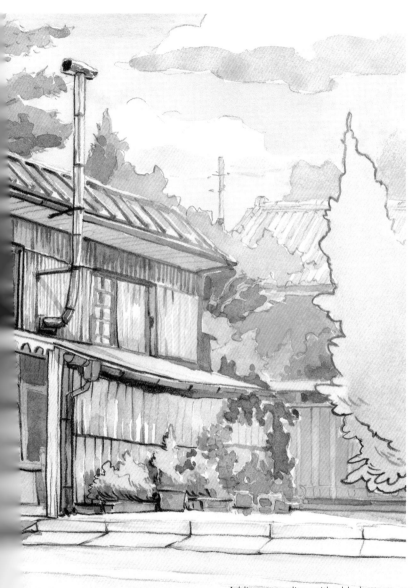

Adding strong lines with a black crayon, even for just a fragment of the picture, adds a terrific sense of depth!

用黑黑的蠟筆在某些部分加上線條，就能營造出非常棒的深度感！

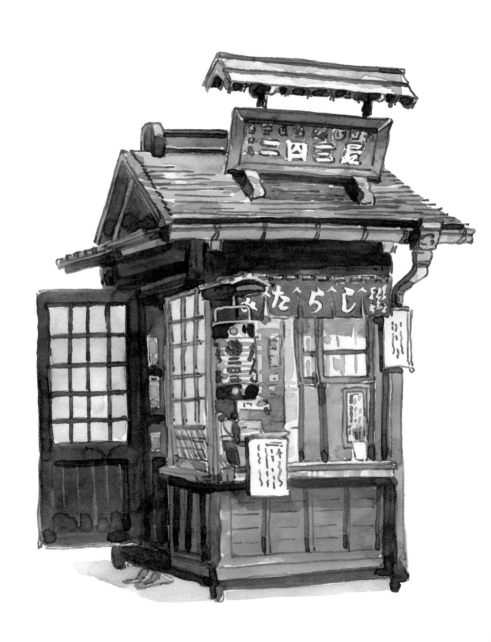

A strange bookstore I painted for use on bookmarks that were sold with the Spanish edition of "Tokyo Storefronts."

為了和西班牙文版《東京老鋪》一起販售的書籤，所畫的一間奇妙書店。

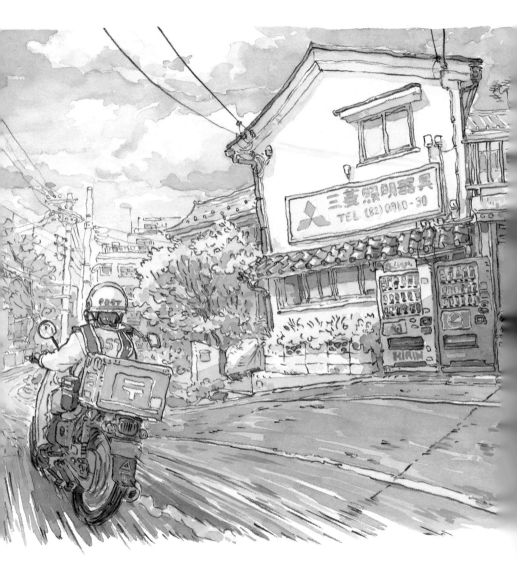

I'm still trying to get the "rough-but-finished" look right in my simpler watercolor-and-pencil paintings.

我還在嘗試單用水彩和鉛筆創作時，讓作品呈現出「看似粗略卻完整」的感覺。

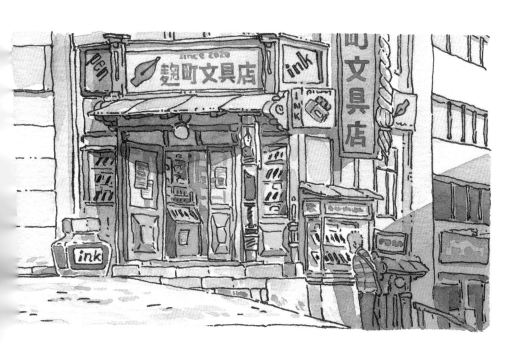

If a display window has art supplies,
I will stop and ogle them intensely.

櫥窗裡擺著畫材時，我總忍
不住停下腳步盯著看。

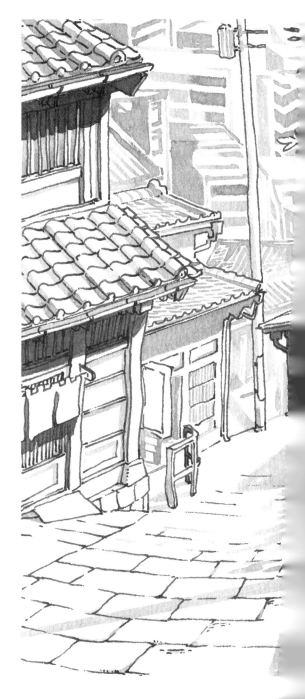

Will an ink painting like this work for a comic background if the book is printed using only black rasters (those dot patterns in Japanese comics)? I will never know as this project was canceled.

用墨水繪製的畫，適不適合用在網點印刷的漫畫背景呢？這個計畫取消了，所以我也不知道答案。

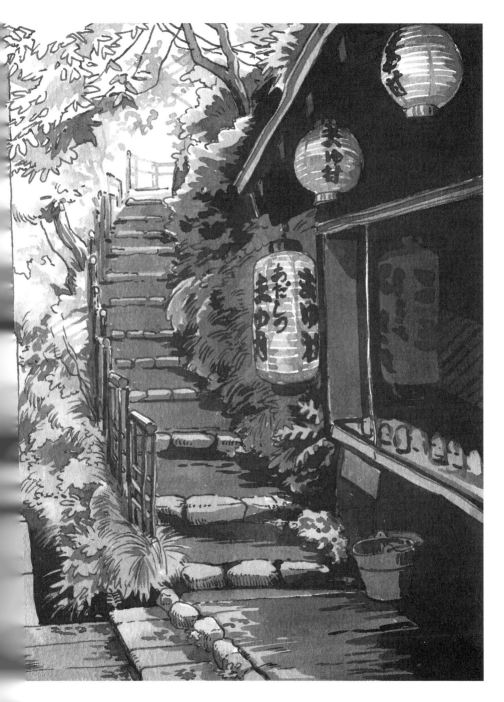

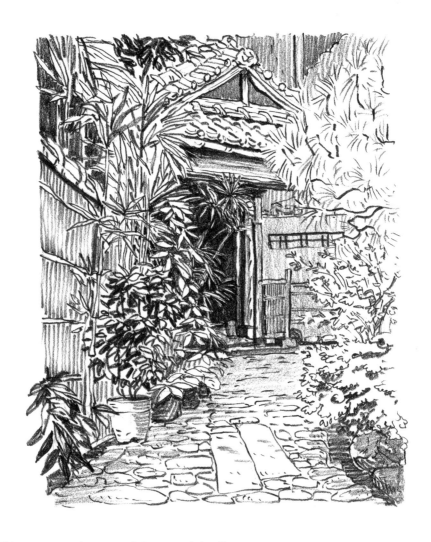

This entrance to a Japanese-style house was lodged in my memory
for years before I found the photo again and sketched it.

在我找出照片並畫出草圖之前，這個日式房屋門口的
場景，已經在我腦海中逗留了好幾年。

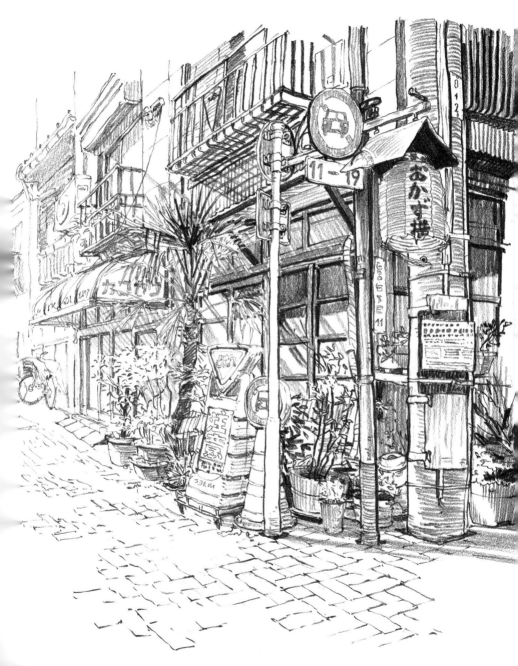

Japanese gardens, parks, and temple gardens offer the perfect amount of tamed nature for my tastes, but even here, I lose to the heat, weather, or mosquitoes, and come back home without having drawn anything. I wish I had a bit more patience for painting outdoors.

日本庭園、公園和寺院的境內，都有我最喜歡的沉靜自然景觀，但即使在這些地方，我也會因為敵不過炎熱、天候或蚊子，什麼都沒畫就回家。對於戶外寫生，我希望可以變得更有耐力才行。

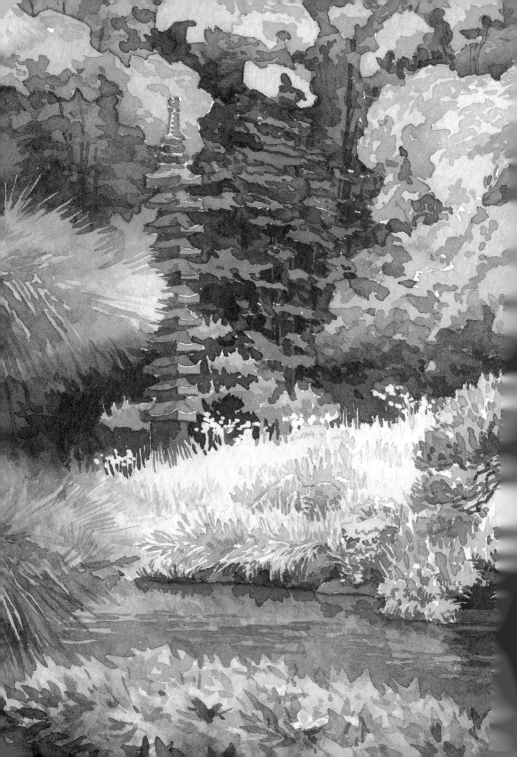

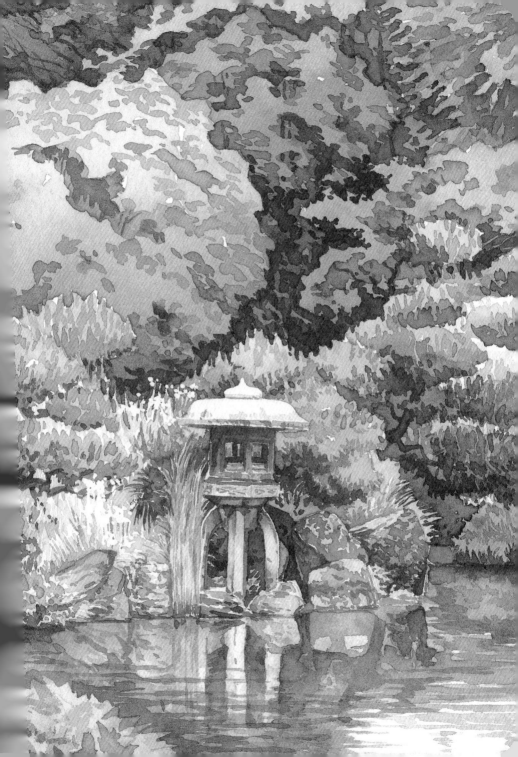

When faced with a garden, I sometimes panic and try to find an architectural element I can place into the picture. Scenes with only nature are still a challenge for me.

畫庭園時，我有時會定不下心，不斷尋找可以畫進畫中的建築物。要畫純粹的自然風景，還需要多加修練。

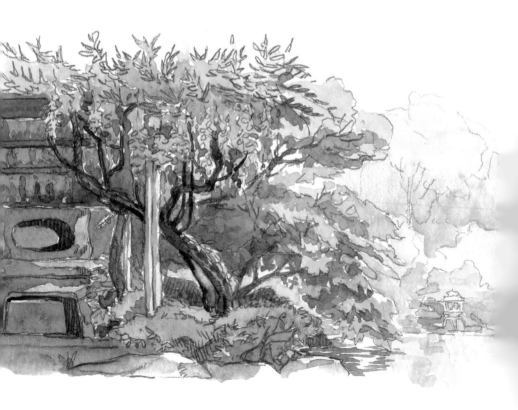

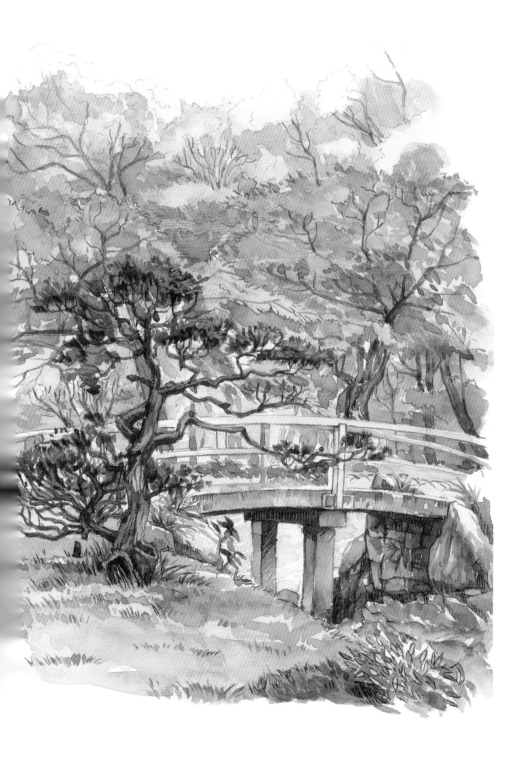

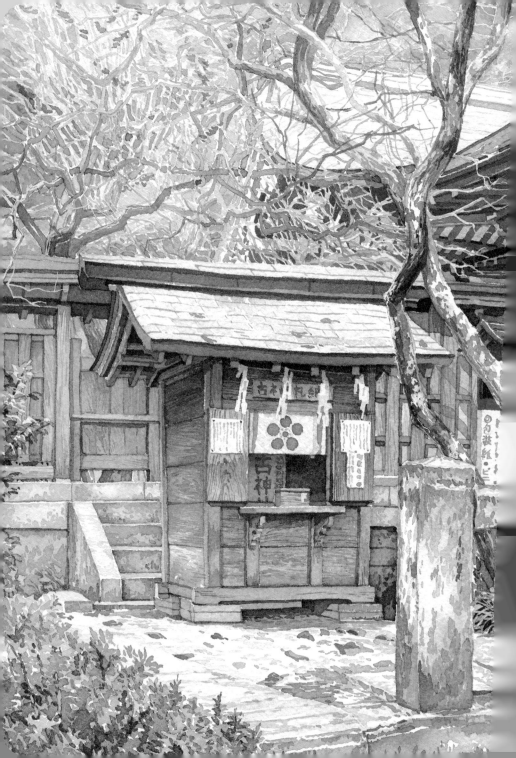

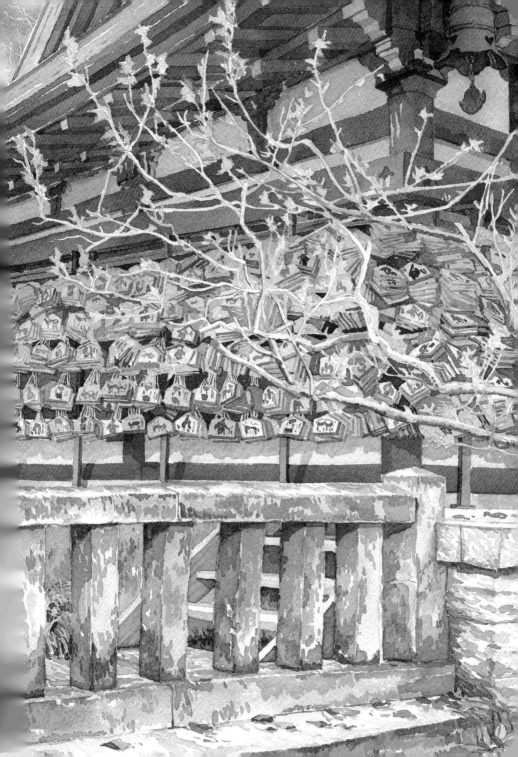

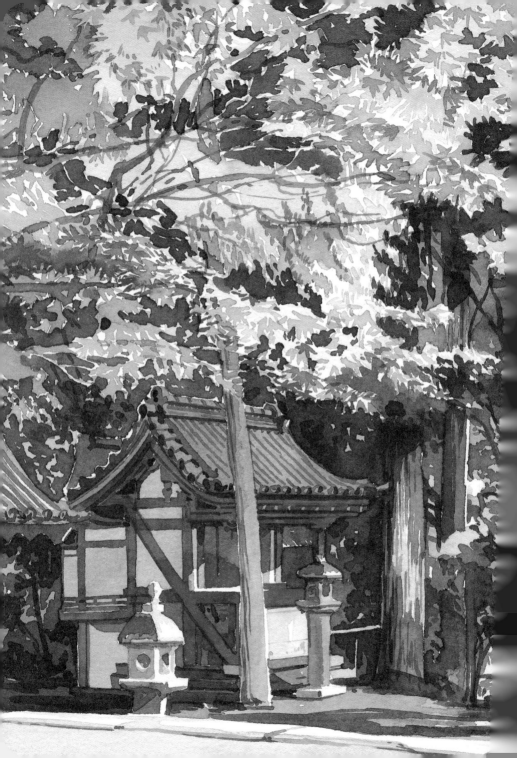

Painting with no pencil underdrawing is simultaneously a thrill and an intense challenge that makes my forehead wrinkle with concentration. Working with waterproof color inks helps a lot – I don't have to stick to the lights-to-darks order at all.

不用鉛筆畫底稿直接畫，對我而言是既刺激又需要高度集中的挑戰，額頭都皺了起來。這時候，不必太過在意明暗順序的耐水性彩墨就變得很好用。

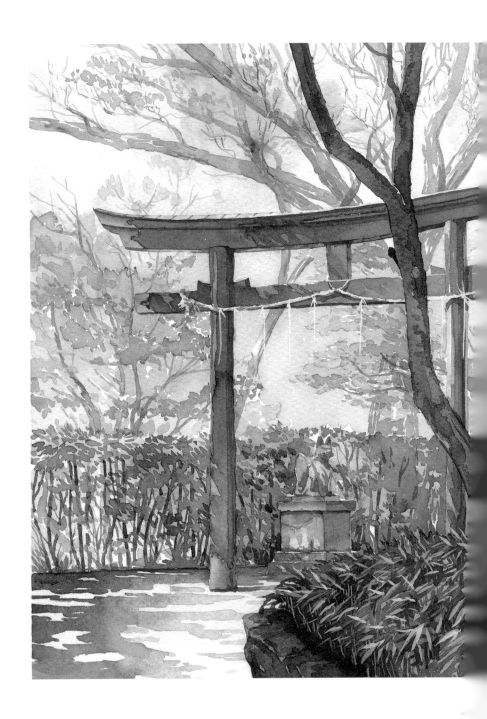

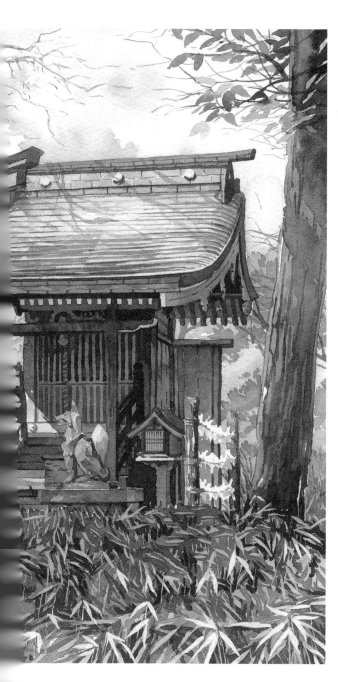

A small shrine in a hotel garden near our house.

住家附近的一間旅館庭園裡，祀奉著一座小神社。

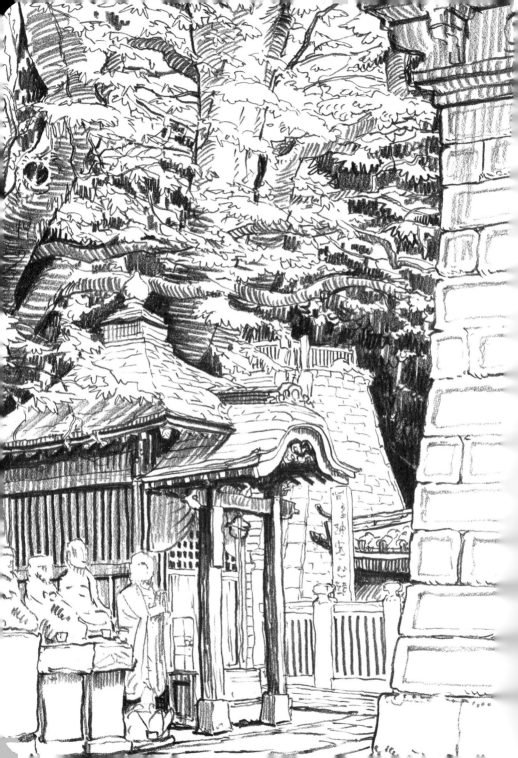

Painting or drawing with unfamiliar supplies
helps retain a bit of that childish glee of
just using the tools and being happy with
whatever comes out.

使用不熟悉的畫材時，會有一種像
孩童時代一樣，單純享受著「使用
工具的樂趣」。而且，成品也更容
易讓人感到滿意。

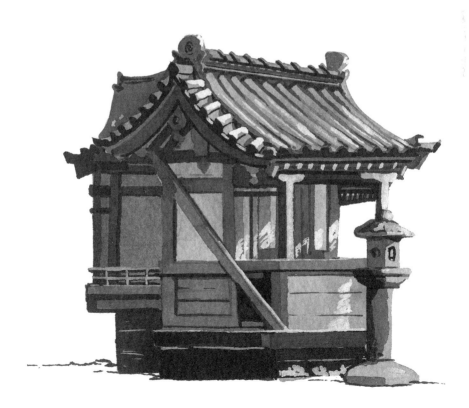

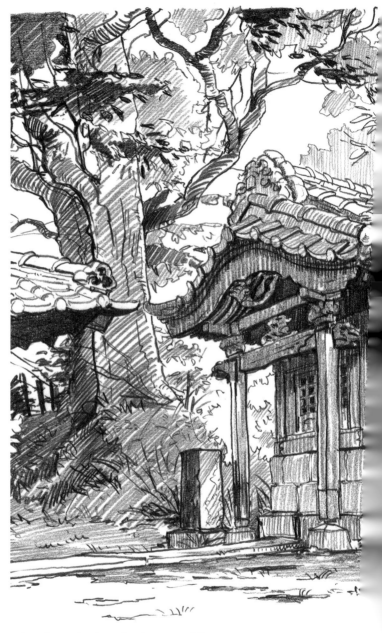

My pencil rendering style is all over the place when it comes to foliage.

我的鉛筆畫中，對於樹木枝葉的描繪方式還是有些混亂。

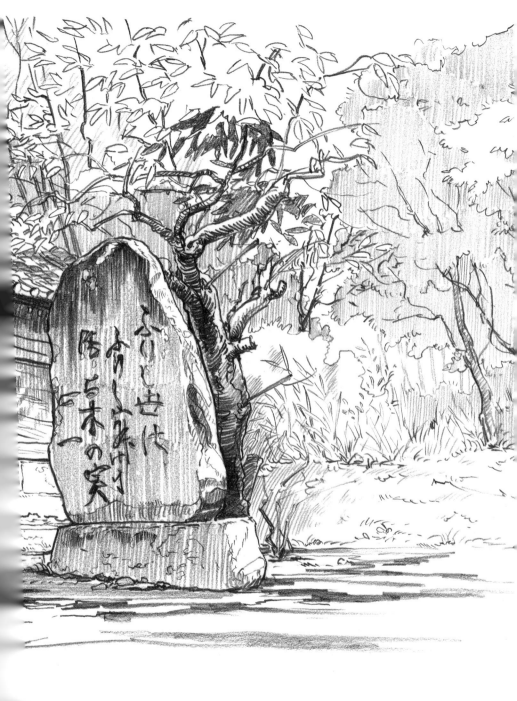

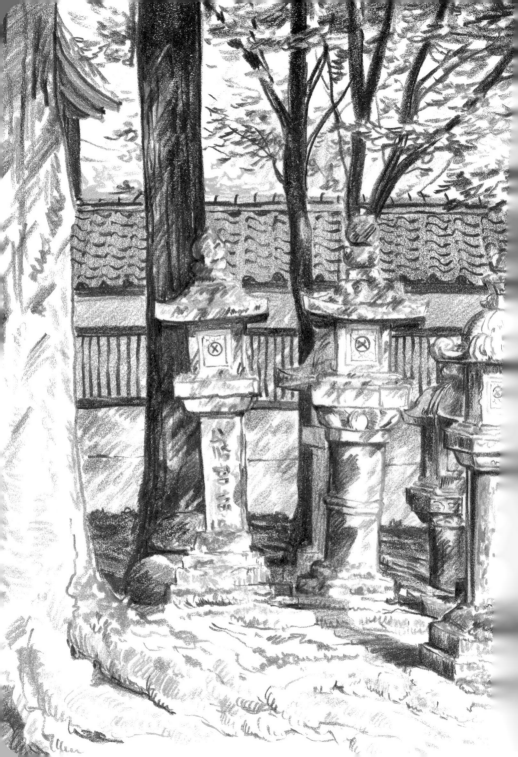

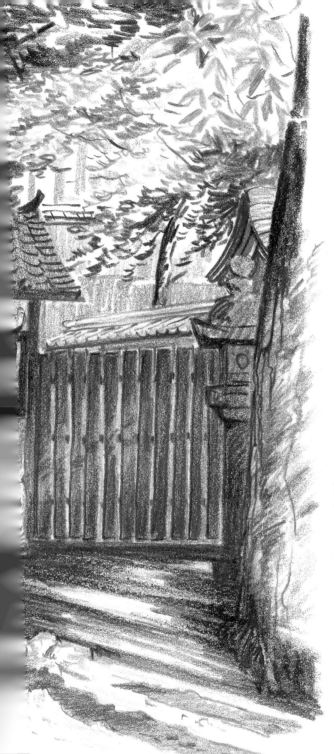

I was having so much fun with some new colored pencils that this quick test turned into a full-fledged drawing without me even noticing.
I like how the white left uncolored in the foreground helps to bring out the contrast between light and shadow.

一開始試用新買的色鉛筆，手就停不下來，不知不覺就畫滿了。最後完成的這幅畫，前景的留白讓光影對比表現得很不錯。

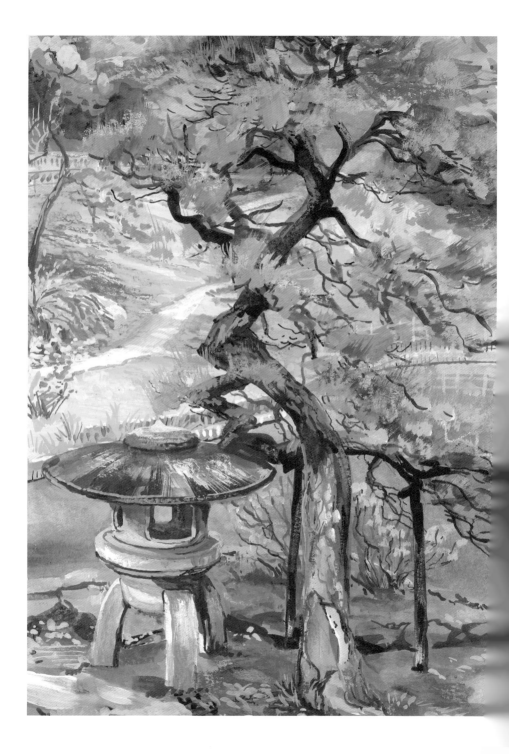

I was allowed to set up my painting tripod under the condition that I stay out of the way of the other visitors. I was also provided with an armband with the garden's logo, showing I had the staff's permission to stand there and paint.

我在遊客較少的地方，得到了放置畫架的許可。我也被配發一個庭園標誌的臂章，以證明有權限站在這裡畫畫。

The entrance to a shrine that was located between the
metro station and the animation studio.
I passed here many times, choosing to go through it
rather than deal with the noisy street.

從地下鐵站到動畫工作室的路上，有個神社
入口。比起嘈雜的街道，我更喜歡從這裡穿
過，所以我經常走這條捷徑。

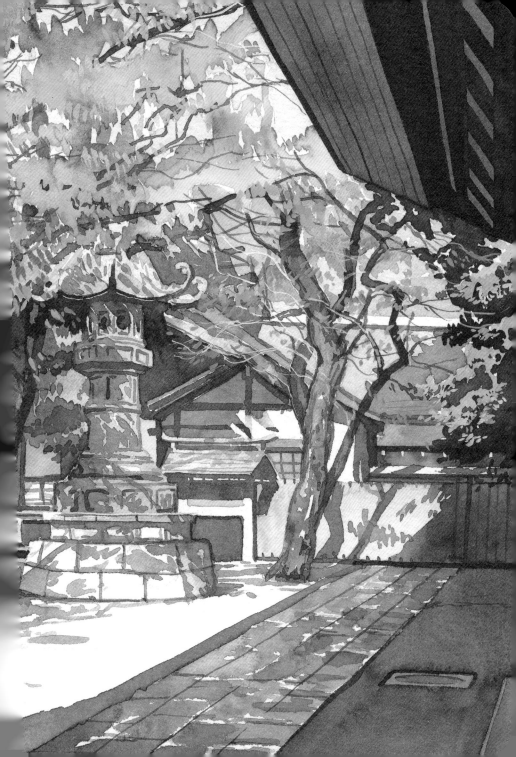

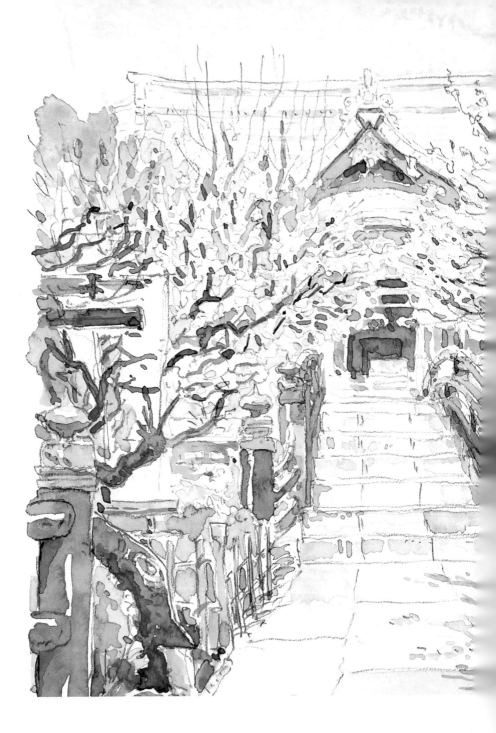

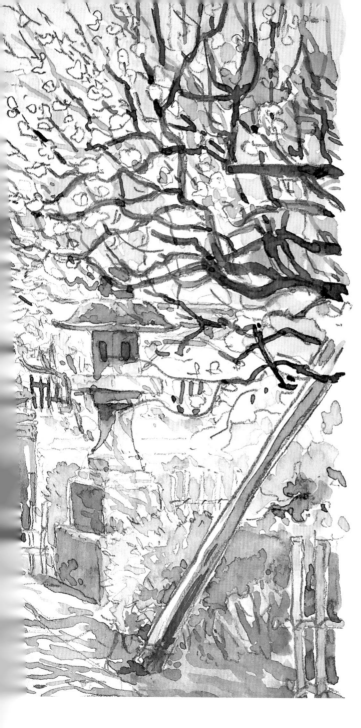

We went to see the
plum blossoms in the
Kameido Tenjin Shrine.

去龜戶天神社觀
賞梅花。

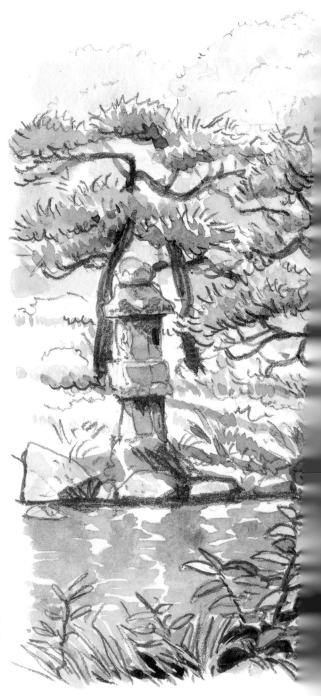

The Kiyosumi Japanese Garden
– it was so brutally hot that
morning that I only managed
the pencil lines while on
location.

清澄庭園。那天從早上開
始就炙熱難耐，在現場只
勉強用鉛筆畫下線條。

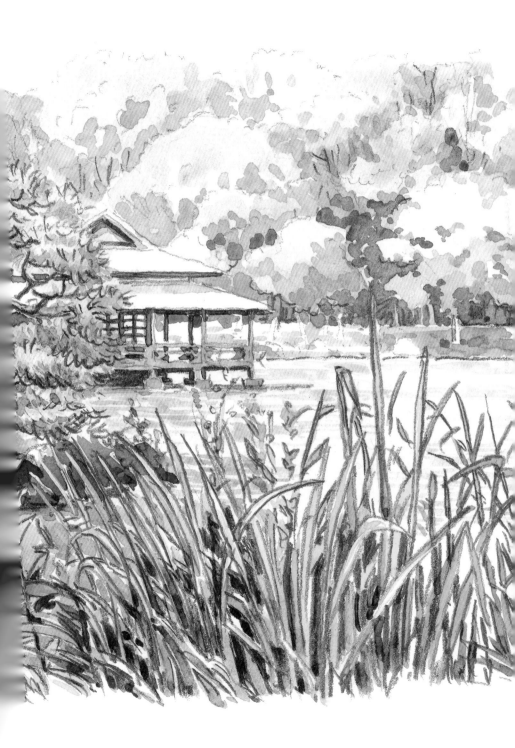

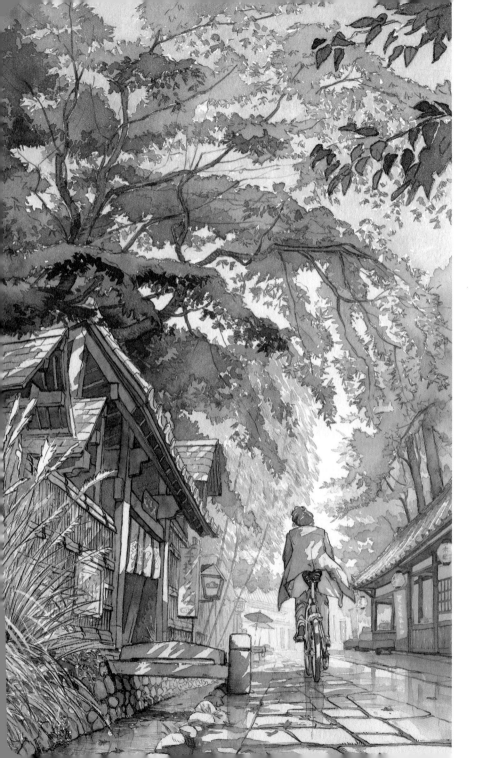

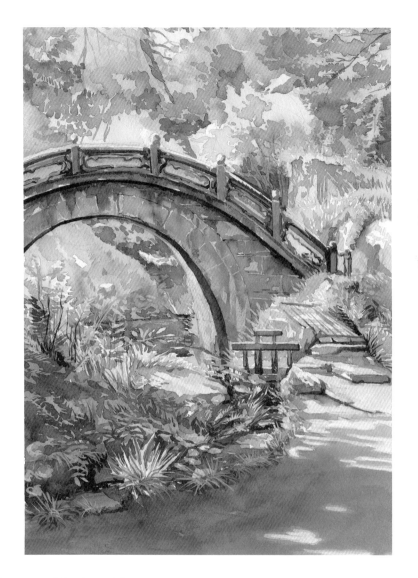

(Left) When I painted this place, I did not imagine that, only a few years later, I would live close by and often walk here with Kana, our son, and our dog, and come to eat great soba too.

（左）我在畫這幅畫時，完全沒想到幾年後會住在這附近，和Kana、兒子、愛犬一起散步、吃蕎麥麵。

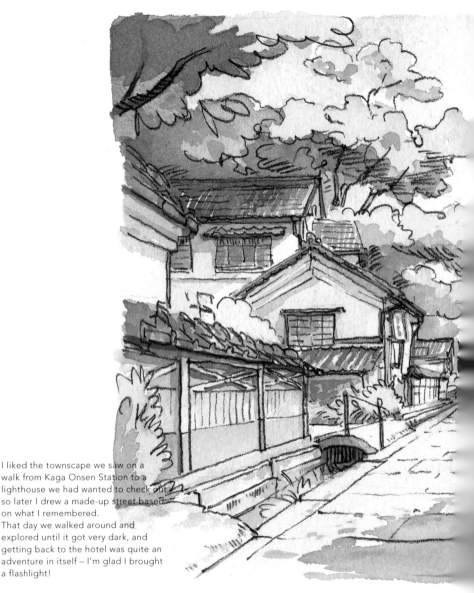

I liked the townscape we saw on a walk from Kaga Onsen Station to a lighthouse we had wanted to check out, so later I drew a made-up street based on what I remembered.
That day we walked around and explored until it got very dark, and getting back to the hotel was quite an adventure in itself – I'm glad I brought a flashlight!

從加賀溫泉車站到燈塔途中,映入眼簾的街景深得我心。所以我一邊回憶,一邊畫出這條街道。我記得那天直到天黑我們都在四處閒逛,已經想不起來是怎麼回到旅館的。幸好帶了手電筒!

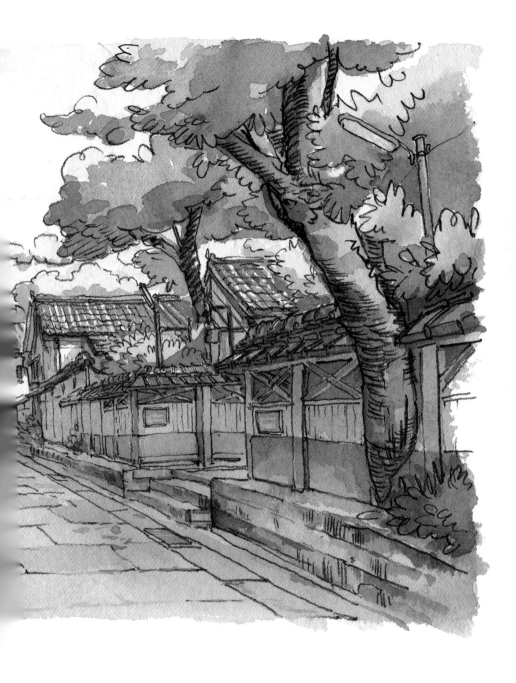

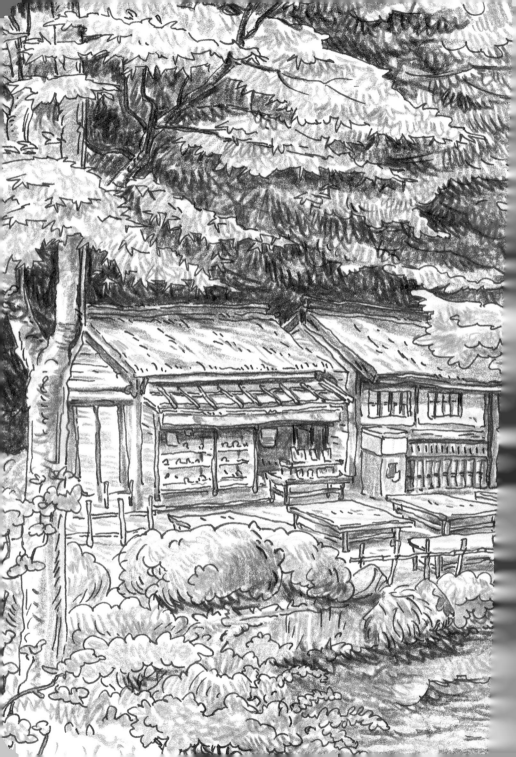

Some shops in the Kenrokuen Garden – Kanazawa. The soft serve we ate at that time was delicious!

位於金澤兼六園內的店鋪。吃到很美味霜淇淋！

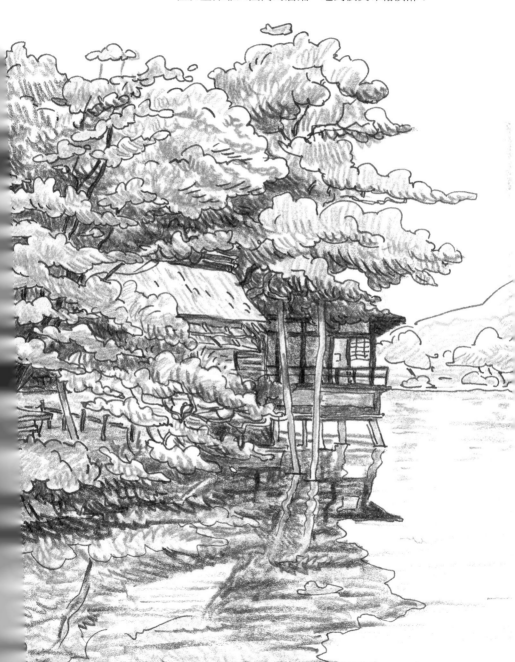

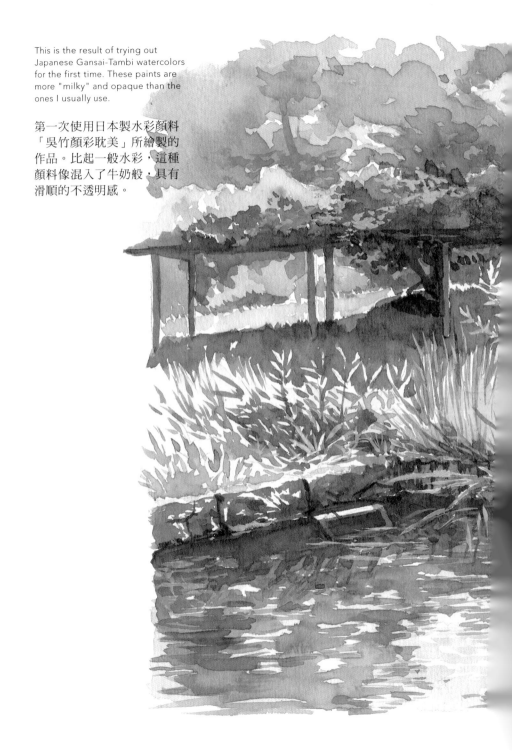

This is the result of trying out Japanese Gansai-Tambi watercolors for the first time. These paints are more "milky" and opaque than the ones I usually use.

第一次使用日本製水彩顏料「吳竹顏彩耽美」所繪製的作品。比起一般水彩，這種顏料像混入了牛奶般，具有滑順的不透明感。

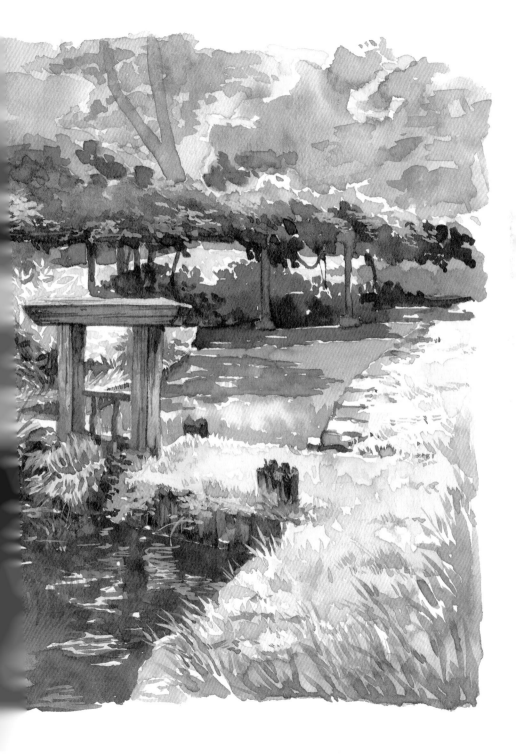

Why is it that sometimes, even with just a random little sketch in my sketchbook, using tools I'm unfamiliar with can get me into the "zone" and turn out so well with so little effort?

不知道為什麼，每次心血來潮拿起不熟悉的繪畫材料隨意速寫時，我會進入「心流狀態」，不用太費力就畫得很順利。

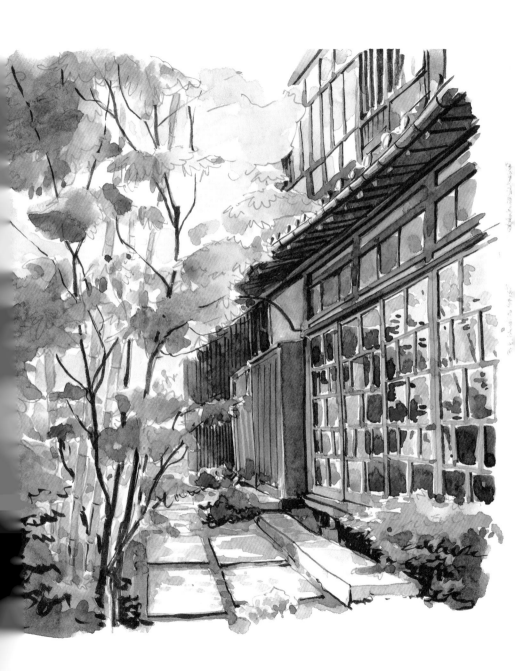

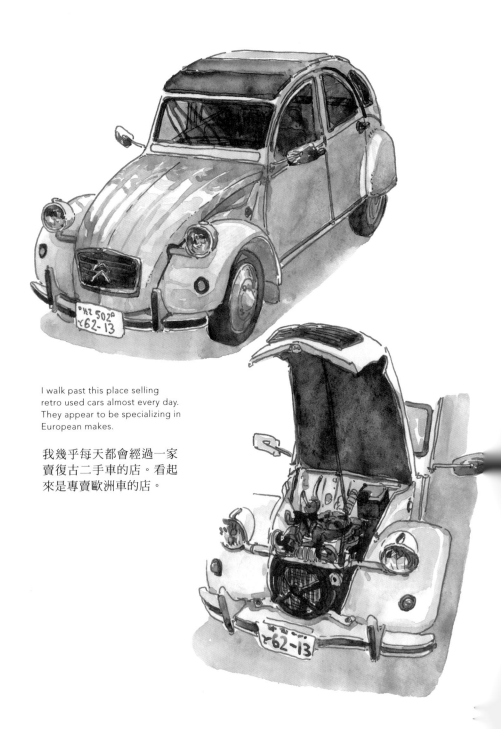

I walk past this place selling
retro used cars almost every day.
They appear to be specializing in
European makes.

我幾乎每天都會經過一家
賣復古二手車的店。看起
來是專賣歐洲車的店。

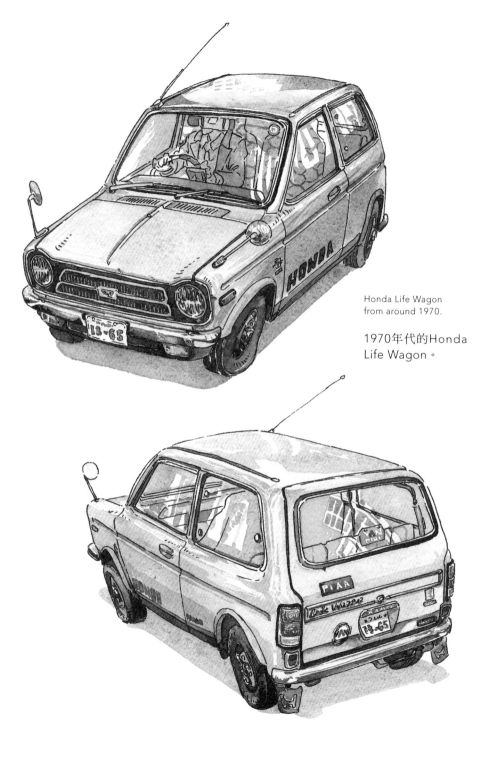

Honda Life Wagon
from around 1970.

1970年代的Honda
Life Wagon。

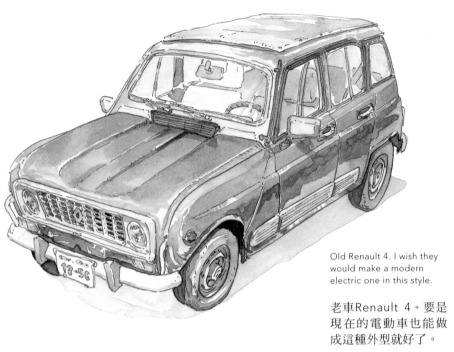

Old Renault 4. I wish they would make a modern electric one in this style.

老車Renault 4。要是現在的電動車也能做成這種外型就好了。

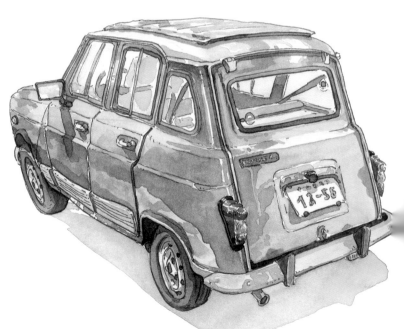

When a lion and a tiger mate, you get a cute truck-car thing, apparently.

車名就像英文的「獅子」加「老虎」，外型可愛的卡車。

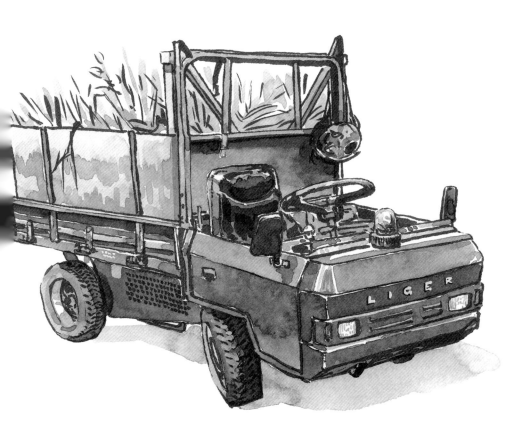

While we lived around Enoshima, these heavy machines were always carrying around and flattening sand on the beach. I don't know what the goal of this was – maybe it's a task that ordinary beach-goers shouldn't be concerned with.

以前住在江之島附近時，總是看到這些重型機械在海邊運沙並將沙鋪平，但始終不知道他們為什麼要這麼做。說不定是一些不能讓一般人知道的任務。

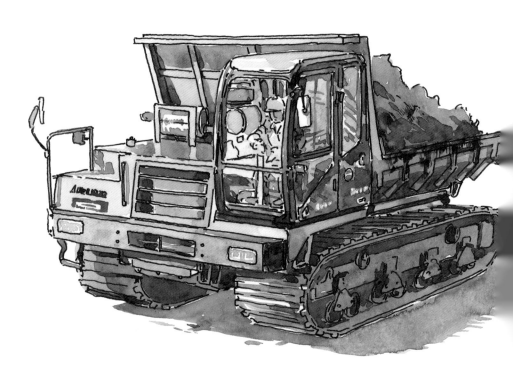

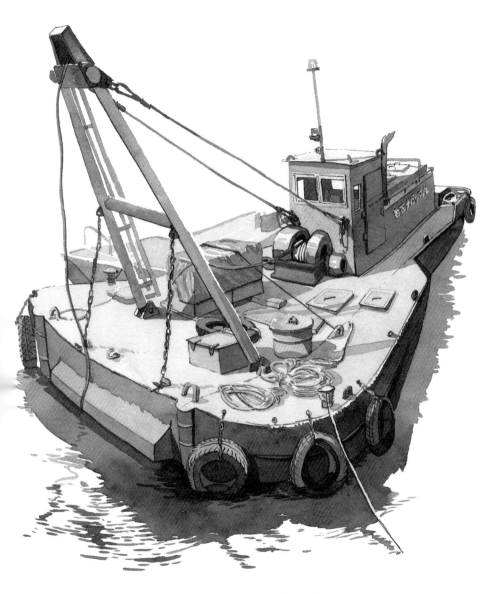

An unusual type of barge I saw near Enoshima.

在江之島附近看到的一艘形狀奇特的駁船。

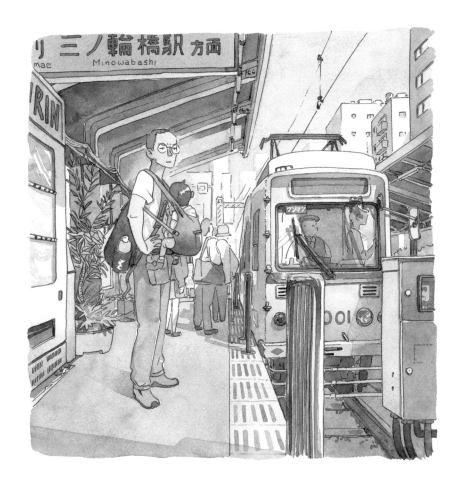

For a while we lived near the Arakawa line – the last old-
school tram line in Tokyo.

東京最後一條古老的路面電車——都電荒川
線。我們曾經在附近住過一段時間。

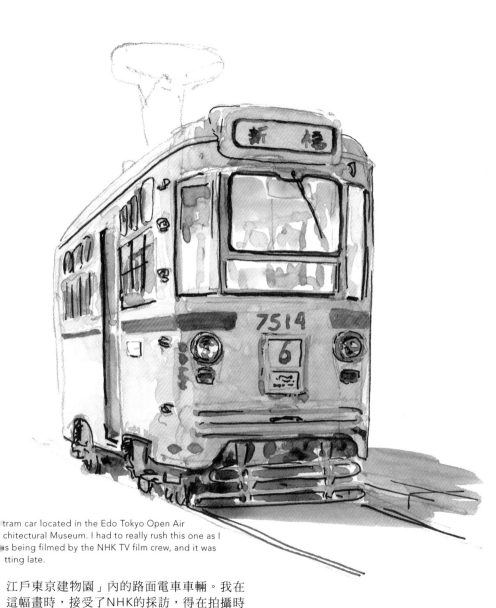

tram car located in the Edo Tokyo Open Air
chitectural Museum. I had to really rush this one as I
s being filmed by the NHK TV film crew, and it was
tting late.

江戶東京建物園」內的路面電車車輛。我在
這幅畫時，接受了NHK的採訪，得在拍攝時
緊畫完，但最後還是花了很長時間才完成。

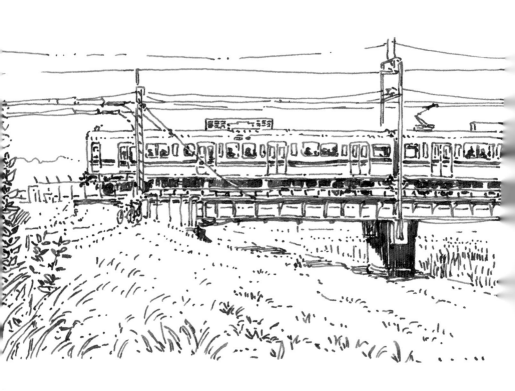

I drew this with a really old Parker fountain pen (that had once been my grandfather's) that was revived for me by a pen specialist in Ginza.

畫這幅畫時，我用的是一支祖父用過的派克鋼筆，年代古老。銀座有一位專門修復鋼筆的師傅，他幫我修復了這支筆。

I stumbled upon this tram car on a sweltering hot day while exploring Tokyo's Arakawa tram line. I wanted to paint more, but the asphalt got so hot beneath my feet that I only managed a quick sketch before running away, fearful of heatstroke. I find these old-style round trams very nostalgic. Perhaps it's because they're similar in shape to the trams in Poland – although still in service in some places, they were already old and obsolete when I was a kid.

某個悶熱的日子在東京都電荒川線上探險時偶遇的車輛。本來想多畫幾張，但腳下的柏油路實在太熱，感覺就要中暑了，所以趕快畫了一張就撤退。看到這種古早的圓滾滾路面電車，總是讓人感到懷舊。也許是因為它的形狀和波蘭的路面電車很像。雖然現在也還有部分在運行，但在我小時候，它們已經算是老舊、過時的東西了。

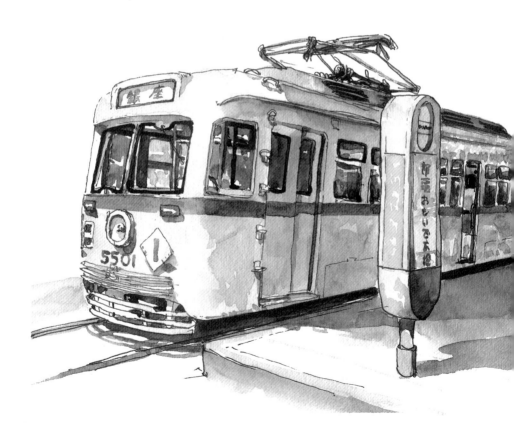

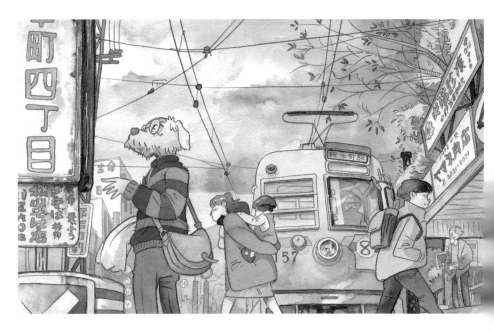

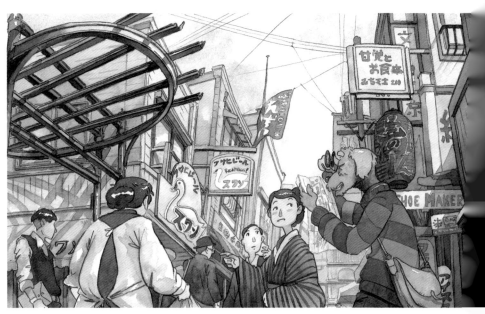

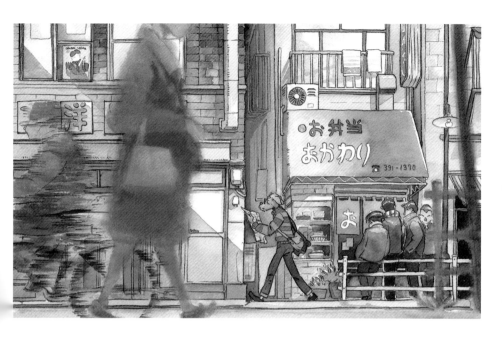

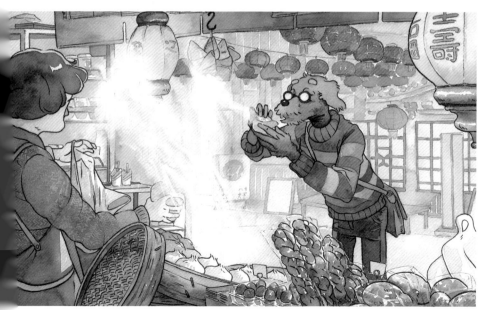

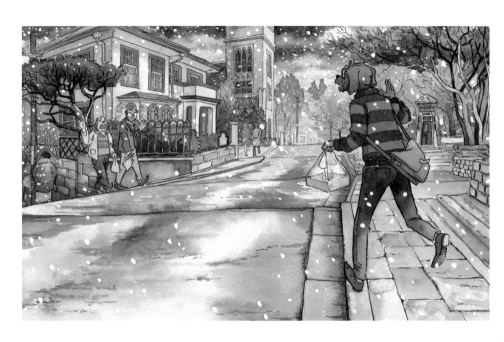

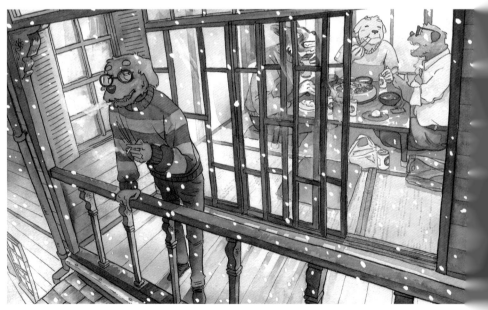

1

I drew this dog character, exploring a fantastic Yokohama, as a rough extension of myself. Maybe that's why he became my art "avatar" of sorts. I had to get rid of the glasses and cigarettes, though.

這隻狗狗角色是我在極為美好的橫濱街道遊逛時，帶著輕鬆的心情繪製的自我延伸角色。從那以後，這隻狗就成為了我藝術創作中如「阿凡達」化身般的存在。雖然眼鏡和香菸不得不拿掉了。

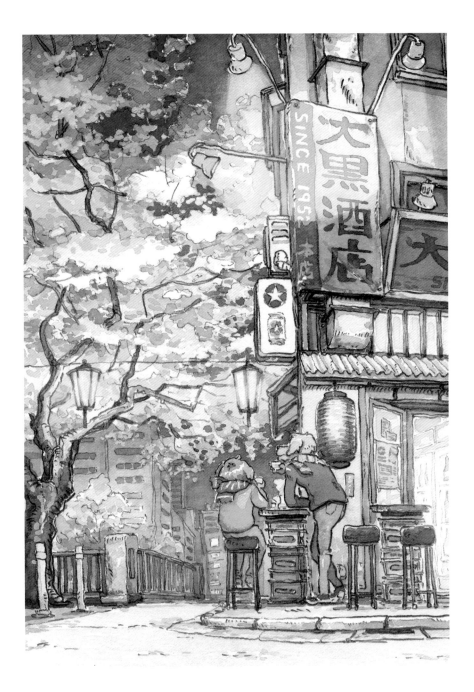

Afterword

This collection of previously unpublished works gathers paintings, drawings, and sketches I did between 2010 and 2021, starting from when I was still working at an animation studio. Painting animated movie backgrounds from morning till evening left me with only late nights or weekends to try do some art of my own.

Still, I always got heaps of inspiration and energy just from roaming around the city, searching for interesting locations and then trying to do something creative with what I found.

I'm happy to discover that, although Japan has become my de facto home, it has lost none of this charm for me. While on a walk with my family, I will abruptly stop talking mid-sentence because I just spotted an interesting building or detail that I simply have to photograph to add to my "library" – someday, it might end up in one of my future works!

Tokyo, Jindaiji, May 2022

結語

這本作品集收錄了我從2010年還在動畫工作室工作時，到2021年之間所畫的水彩畫、素描和速寫，這些作品在成書時（2022年）都未曾在其他地方發表。從早到晚一直在畫動畫的背景，自己的創作只在深夜或週末進行。即使如此，漫遊在街頭尋找有趣的地點，並用新的發現去創作仍是我最大的動力。

現在日本已成為我的第二故鄉，而它的魅力依舊，令我由衷感到高興。

當我和家人一同散步聊天時，有時也會突然停止對話。因為如果發現了有趣的建築或裝飾，就必須拍下照片加到我的圖庫中。我相信，這些東西有朝一日會化身為我未來的作品。

東京・深大寺・2022年5月

Credit

p.005,166 /《趣味的文具盒》（趣味の文具箱）2021年4月號vol.57，株式会社ヘリテージ

p.006-007,008,009,014-015,020-021 / 為動畫作品〈前進吧，卡洛琳娜。〉描繪的插圖，大塚製薬株式会社，2018年

p.040-041 /《趣味的文具盒》2021年7月號vol.58，株式会社ヘリテージ

p.083 /《江之島貓森食堂》（江の島ねこもり食堂）ポプラ文庫，名取佐和子　著，株式会社ポプラ社，2018年

p.117 /《趣味的文具盒》2021年1月號vol.56，株式会社ヘリテージ

p.148 /《地鐵指南》（メトロガイド）2017年10月號封面，日刊工業新聞社

Thanks

I would like to give a huge thanks to my wife (and excellent artist) Kana, for teaching me how to be a better – and more patient – artist and person. Many thanks to my parents for supporting my choices, and the animation studio staff who took me in, taught me, and then let me go off to do my own projects.

Last but not least a big thanks to my fans all over the world and to my Patreon supporters – it's thanks to you I'm able to see meaning in what I'm doing.

致謝

首先，我要向我的妻子、優秀的藝術家Kana獻上最大的感謝。我從她身上學到作為一個藝術家如何成長，以及如何成為更穩健的人。感謝我的父母支持我所選擇的道路。以及接納我、指導我，並在我獨立時痛快地送我出去的動畫工作室的工作人員們。

最後，我要向對我而言非常重要的全球粉絲和我在Patreon上的支持者們，獻上特別的感謝。我能夠在自己的創作活動中找到意義，都是因為你們。謝謝。

日本散步 Mateusz Urbanowicz Sketches Collection

原文書名　　マテウシュ・ウルバノヴィチ お蔵出し
作　　者　　Mateusz Urbanowicz
譯　　者　　張成慧

總 編 輯　　王秀婷
責任編輯　　李 華
校　　對　　陳佳欣

發 行 人　　涂玉雲
出　　版　　積木文化
　　　　　　104台北市民生東路二段141號5樓
　　　　　　電話：(02) 2500–7696｜傳真：(02) 2500–1953
　　　　　　官方部落格：www.cubepress.com.tw
　　　　　　讀者服務信箱：service_cube@hmg.com.tw
發　　行　　英屬蓋曼群島商家庭傳媒股份有限公司城邦分公司
　　　　　　台北市民生東路二段141號2樓
　　　　　　讀者服務專線：(02)25007718–9｜24小時傳真專線：(02)25001990–1
　　　　　　服務時間：週一至週五09:30–12:00、13:30–17:00
　　　　　　郵撥：19863813｜戶名：書虫股份有限公司
　　　　　　網站：城邦讀書花園｜網址：www.cite.com.tw
香港發行所　　城邦（香港）出版集團有限公司
　　　　　　香港灣仔駱克道193號東超商業中心1樓
　　　　　　電話：+852–25086231｜傳真：+852–25789337
　　　　　　電子信箱：hkcite@biznetvigator.com
馬新發行所　　城邦（馬新）出版集團 Cite（M）Sdn Bhd
　　　　　　41, Jalan Radin Anum, Bandar Baru Sri Petaling, 57000 Kuala Lumpur, Malaysia.
　　　　　　電話：(603) 90578822｜傳真：(603) 90576622
　　　　　　電子信箱：cite@cite.com.my

封面完稿　張倚禎
製版印刷　上晴彩色印刷製版有限公司

日本散步：Mateusz Urbanowicz Sketches Collection/Mateusz Urbanowicz作；張成慧譯. -- 初版. -- 臺北市：積木文化出版：英屬蓋曼群島商家庭傳媒股份有限公司城邦分公司發行, 2023.10
　面；　公分
譯自：マテウシュ・ウルバノヴィチ：お蔵出し
ISBN 978-986-459-525-9(平裝)

1.CST: 繪畫 2.CST: 畫冊 3.CST: 日本東京都

947.5　　　　　　　　112013736

城邦讀書花園
www.cite.com.tw

MATEUSZ URBANOWICZ OKURADASHI 2010-2021
Copyright © 2022 Mateusz Urbanowicz
Chinese translation rights in complex characters arranged with MdN Corporation through Japan UNI Agency, Inc., Tokyo
2023 CUBE PRESS, A DIVISION OF CITE PUBLISHING LTD. All rights reserved.

【印刷版】
2023年 10 月 19 日　初版一刷
售　價／NT$600
ISBN 978-986-459-525-9